ART AND PHOTOGRAPHY:
FORERUNNERS AND INFLUENCES

ART AND PHOTOGRAPHY:

FORERUNNERS AND INFLUENCES

SELECTED ESSAYS BY

HEINRICH SCHWARZ

EDITED BY WILLIAM E. PARKER

THE UNIVERSITY OF CHICAGO PRESS

Chicago and London

Grateful acknowledgement is made to the publications in which the following essays first appeared: "Art and Photography: Forerunners and Influences" in *Magazine of Art* 42:11 (November 1949); "Vermeer and the Camera Obscura" in *Pantheon: Internationale Zeitschrift für Kunst* XXIV: No. III (May/June 1966); "Daumier, Gill and Nadar" in *Gazette des Beaux-Arts* Series VI: Vol. XLIX (February 1957).

Grateful acknowledgements are also extended to Mrs. Elisabeth Schwarz, Heinrich Schwarz's widow, for providing translations of foreign language material; to Mr. Peter Galassi, Associate Curator, Department of Photography, The Museum of Modern Art, Mr. Gene Thornton, critic for *The New York Times,* and Dr. John T. Spike, historian of Italian art, for sharing their own preliminary transcriptions of "Before 1839: Symptoms and Trends."

The University of Chicago Press, Chicago 60637
The University of Chicago Press, Ltd., London
© Visual Studies Workshop, 1985
All rights reserved. Published 1985
University of Chicago Press edition 1987
Printed in the United States of America

96 95 94 93 92 91 90 89 88 87 5 4 3 2 1

Library of Congress Cataloging-in-Publication Data

Schwarz, Heinrich, 1894–1974.
 Art and photography.

 Bibliography: p.
 1. Photography—History. I. Parker, William E.
(William Edward), 1932– . II. Title.
TR15.S395 1987 770'.9 87-10763
ISBN 0-226-74234-2 (pbk.)

CONTENTS

INTRODUCTION

H EINRICH SCHWARZ (1894-1974), "Museum Curator and Educator," as he typically and all-too-modestly identified his professional activities, was born in Prague, Czechoslovakia. During 1913-14 he studied history of art, classical archaeology and philosophy at the University of Vienna. In 1918, following military service, he engaged advanced studies in art history at the University of Vienna, concentrating on 18th-, 19th- and 20th-century painting and sculpture, receiving his doctorate in 1921. His doctoral thesis concerning the beginnings of lithography in Vienna initiated his lifelong, internationally recognized art historical and curatorial contributions, particularly those contributions concentrated in the field of the graphic arts.

During the early 1920s in Vienna, Heinrich Schwarz began his curatorial career in the Print Room of the Albertina Museum. From 1923 to 1938, at Vienna's Austrian State Gallery in the Belevedere Palace, he was appointed to major curatorial positions, participating in the establishment of the Baroque Museum, the Gallery of the 19th Century, and the Modern Gallery. In 1929 at the Modern Gallery, pursuing his evolved research interests in early photography, Dr. Schwarz organized an exhibition of 180 calotype photographs from the 1840s by the Scottish painter D.O. Hill with recognition of Hill's collaborator, the Edinburgh photographer Robert Adamson, as technical aid. Through further research and extension of his initial catalogue commentary for the exhibition, Heinrich Schwarz became the very first art historian to write a scholarly monograph on a photographer, emphasizing what he believed to be "artistically remarkable documents of a strange union between a mechanically operating apparatus

and the creative and organizing will of the human spirit direct-
ing the machine." His *David Octavius Hill, der Meister der
Photographie* (Leipzig, 1931), which was, shortly after its ini-
tial publication, enlarged, translated and published in London
and New York, remains a continuously influential assessment
of the Hill and Adamson calotypes and a major contribution to
the history of photography.

Heinrich Schwarz arrived in the United States in 1940 and
was soon appointed Research Scholar and Resident Assistant
at the Albright Art Gallery in Buffalo, New York. From 1943
to 1953, he served as Curator of Paintings, Drawings and
Prints at the Rhode Island School of Design Museum of Art
(Providence). In 1954 he was appointed Curator of the Davi-
son Art Center Collection and Professor of History of Art at
Wesleyan University (Middletown, Connecticut), serving
there until his retirement in 1972.

Excerpts from two of the privately published *Eulogies* deliv-
ered at the funeral service for Heinrich Schwarz on September
23, 1974, especially identify the character of his professional
interests and contributions. Richard S. Field, at the time
Curator, Davison Art Center, and now Curator of Prints,
Drawings and Photographs, Yale University Art Gallery,
wrote:

> Heinrich Schwarz ... personified the ideals of quality
> so inextricably associated with the discipline of art his-
> tory and the profession of curator.... As a scholar
> trained in the tradition of European humanism, Hein-
> rich embraced the entire gamut of art history from the
> late Middle Ages down to the early decades of our own
> Century. His research and publications ranged from
> exhaustive and meticulous investigations of Renais-
> sance iconology to the first stylistic assessment of pho-
> tography.... His knowledge, files, and publications of
> the development of nineteenth-century lithography,
> based upon fifty years of research, produced dozens of
> indispensable contributions which today are encoun-
> tered in every younger scholar's work. His knowledge
> of the last 300 years of Austrian art—the area in which

he took his Ph.D. in 1921—never diminished despite the fact that the last 34 years of his life were passed in the United States. . . . To be sure, Heinrich was an intellectual and curatorial elitist, but future students, scholars, and viewers will be the richer for it. . . . He was one of that phalanx of exiled scholars who established the discipline of art history in America and profoundly altered our understanding of and our very relationship to the past.

In his personal tribute, Alan Shestack, Director, Yale University Art Gallery, stated:

Heinrich will, of course, be remembered not only by the fortunate few who were his students at Wesleyan, but also by the scholarly world. His interests were extremely wide-ranging and his scholarly writings covered a broad spectrum. He was equally at home writing about Renaissance drawings, early lithography, Baroque art, 19th and 20th century Austrian art, and about photography. His interests and knowledge were so broad, in fact, that they extended far beyond the limits of standard art history. His understanding of certain aspects of technology, optics for example, led to some of his most fascinating art historical discoveries. Although his training was deeply rooted in the best traditional art history (he had studied with Schlosser and Dvořák), he was an incredibly courageous scholar, willing to wade into uncharted waters. He wrote about photography as an art form, not only long before it became a fashionable subject—but at a time when he was, in fact, the only scholar in the world approaching photography from an art historical point of view, writing about the relationship between art and photography and taking photographers seriously as artists. By virtue of his perceptions and intuitions he anticipated what eventually became a major concern of our field. He was really *the* pioneer in this realm of the history of art.

Residual in Heinrich Schwarz's estate are impressively extensive research documents, bibliographical and pictorial materials, and preliminary writings, revealing his having intended to prepare a thorough study of the relationships between science and art defined in interpenetrative historical developments of photography and other pictorial arts. Despite the fact that Dr. Schwarz's intended *"magnum opus"* was not achieved, his realized pioneering contributions concerning photography's historical evolution and relationship with traditional arts have been recognized by other historians concerned with similar issues, especially Beaumont Newhall in his many published writings and lectures on the history of the art of photography, Aaron Scharf in *Art and Photography* (1968), and Van Deren Coke in *The Painter and the Photograph* (1964, 1972). The most recent recognition of Dr. Schwarz's seminal contributions is evidenced in the book by Peter Galassi, *Before Photography: Painting and the Invention of Photography* (1981), published to accompany an exhibition of the same title directed by Galassi, Associate Curator in the Department of Photography at The Museum of Modern Art (New York), for presentation by the museum and a national tour during 1981-82. In a note on Heinrich Schwartz's article, "Art and Photography: Forerunners and Influences" (*Magazine of Art*, Vol. 42, No. 7, Nov. 1949), with further reference to the origins of the idea for the exhibition, Galassi writes in *Before Photography* (*Notes*, 2., p. 30):

> The late Professor Schwarz was a pioneer in the critical evaluation of this issue. Although his later publications do not depart from the spirit of the 1949 article, Schwarz apparently modified his views as he pursued the subject. Of particular importance is an unpublished lecture, "Before 1839: Symptoms and Trends," first delivered at the 1963 meeting of the College Art Association, in Baltimore. John Szarkowski, Director of the Department of Photography at The Museum of Modern Art, was deeply impressed by the lecture and its illustrative materials. His interest in the issue, prompted by Schwarz's lecture, eventually led to plans

for the present exhibition. However, his efforts to ob-
tain a transcript of the lecture were unsuccessful, des-
pite the kind assistance of Professor Schwarz's widow.
The only record of the lecture is to be found in the
Year Book of the American Philosophical Society
(1963), p. 600: The lecture "deals particularly with
observations on pre-photographic paintings of the
1820s and 1830s; that is to say, with paintings of the
last two pre-photographic decades in which already
strong 'photographic' features can be observed even if
these paintings were done without the aid of any
mechanical device. The introduction of the paper con-
cerned with pre-photographic mechanical aids and de-
vices used by artists from the fifteenth century on-
wards pointed to the interdependence of science and
art."

From first appearance, Peter Galassi's exhibition and book
have continued to profoundly interest many professionals con-
cerned with art history, critical inquiry and museology.
Galassi's several references to Heinrich Schwarz's precursive
scholarship and the crediting of the 1963 College Art Associa-
tion lecture as an inspirational source for the exhibition ini-
tially motivated this edition of Dr. Schwarz's previously pub-
lished and unpublished writings and transcribed lectures.
Beginning with extracts from three typescripts which iden-
tify Heinrich Schwarz's broader views concerning ontological
aspects of photography, its historical emergence and influence
on pictorial conceptions, *Art and Photography: Forerunners
and Influences* includes a reprint of the 1949 article of the same
title to figure as most publicly representative of Schwarz's spe-
cific views on photography and its developmental import in
the study of interdependent aspects of science and art. Also re-
nascent are two of Dr. Schwarz's signally important essays:
"Vermeer and The Camera Obscura," urging art historical
scholarship to reckon with recurrent problems concerning pic-
torial conceptions and manifestations during the 17th and
18th centuries that require consideration of the actual and
probable use of optically assisting mechanical contrivances by

artists and scientists of those periods and the apparent impact of such contrivances on their work; "Daumier, Gill and Nadar," concerned with issues of attribution and concentrating on reciprocally influential relationships between photography and other pictorial media during the 19th century.

Of most signal import, *Art and Photography: Forerunners and Influences* introduces a transcription of a tape-recorded second presentation of "Before 1839: Symptoms and Trends," delivered by Heinrich Schwarz in Rochester, New York, during November, 1964, as keynote speaker for a Symposium on the History of Photography sponsored by George Eastman House in collaboration with the national Society for Photographic Education. In Dr. Schwarz's introductory remarks to the audience attending the 1964 symposium, he announced his presentation to be but a *"somewhat revised version"* of the paper bearing the same title originally delivered at the 1963 meeting of the College Art Association in Baltimore, Maryland. The original paper initiated the section on Art and Photography included in subsequent annual programs of the College Art Association, the recognition of the section and its inclusion having been born of Heinrich Schwarz's recommendation. Fortunately, Nathan Lyons, at the time Associate Director and Curator of Photography at the George Eastman House, taped Heinrich Schwarz's 1964 Symposium presentation for research reference. Having for many years also encouraged wider recognition of Dr. Schwarz's pioneering contributions to studies in photography, Lyons, founder and Director of the Visual Studies Workshop in Rochester, informed Galassi of the tape held in the V.S.W. Resource Center and provided for its review. Gene Thornton, photography critic for *The New York Times*, after hearing the tape, also recognized that, although not Dr. Schwarz's final publication on the subject, the 1964 presentation revealed his latest, most comprehensively defined views concerning photography's pre-history and place in Western art. Thornton joined Galassi and Lyons in encouraging its publication. The Visual Studies Workshop Press has sponsored the revival of the second version of "Before 1839: Symptoms and Trends," along with other contributions deliberately chosen to correlate with, and

even repeat, certain research attentions, and reveal the development and amplification of Dr. Schwarz's views defined in the 1964 Symposium address. *Art and Photography: Forerunners and Influences* has been prepared with the authorization of Mrs. Heinrich Schwarz and assisted by a publications grant from the National Endowment for the Arts.

This collection of writings and lectures by Heinrich Schwarz is not intended to evaluate his contributions nor to annotate or update scholarship and studies relative to his themes evolved by others prior to or during his lifetime and thereafter. Rather, *Art and Photography: Forerunners and Influences* is intended to serve as a sourcebook for educators and students concerned with art historical and picture-making disciplines, and as a supplemental resource for those interested in pursuing a thorough study of the origins and development of photography and the mutually influencing interactions between photography and other pictorial forms. Certainly any such thorough study will require recognition of Heinrich Schwarz's insights and historical consciousness. And, with equal certainty, the purpose of *Art and Photography: Forerunners and Influences* will be ensured by its having stimulated further investigations which recognize, in Dr. Schwarz's words,

that any profound treatment of 19th-century art and that of the art of the last five centuries requires an interpretation that takes into account ... the link between science and art with all its consequences. Photography is but the final culmination of a long development and must not be studied historically as an isolated phenomenon of the 19th and 20th centuries. For the spirit of photography is much older than its history.

William E. Parker
Professor of Art and History of Photography
Department of Art, School of Fine Arts
The University of Connecticut (Storrs).

PLATES

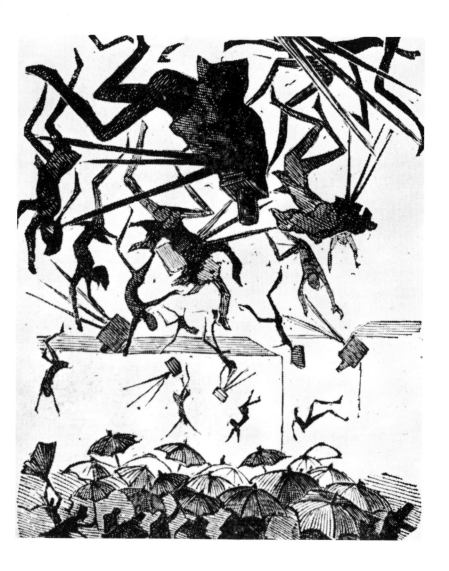

Nadar (Gaspard Félix Tournachon), *"Pluie de photographes,"* wood engraving after original cartoon, from *Journal pour Rire,* 1855.

PLATE 1

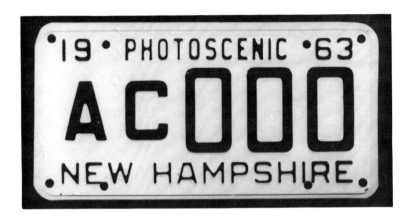

New Hampshire License Plate, 1963.
Heinrich Schwarz Estate, New York.

PLATE 2

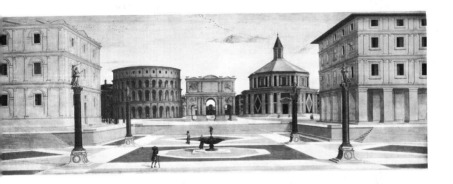

Attributed to Central Italian School, *View of an Ideal City,* c. 1490–1495.
Walters Art Gallery, Baltimore, Maryland.

PLATE 3

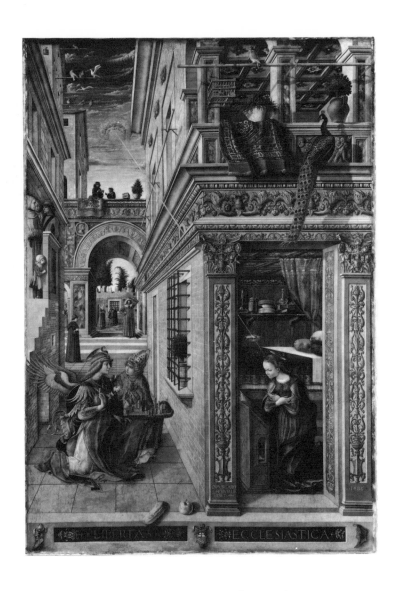

Carlo Crivelli, *Altarpiece: The Annunciation with St. Emidius*, 1486.
National Gallery, London.

PLATE 4

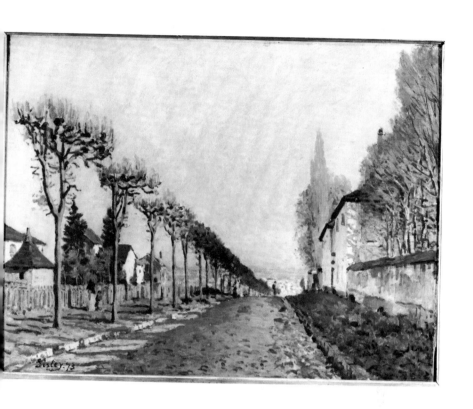

Alfred Sisley, *House of Madame Du Barry (Louveciennes—le Chemin de Sèvres),* 1873.
The Louvre, Paris.

PLATE 5

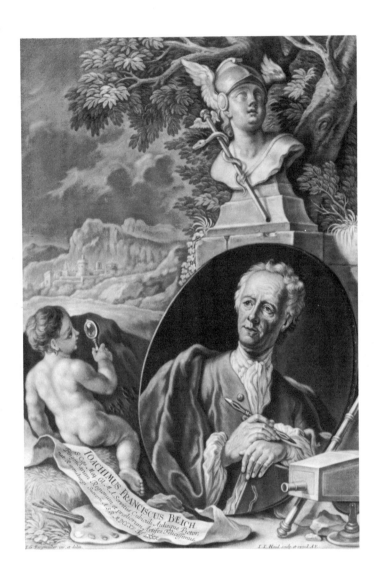

Georg Desmarées, *Portrait of the Court Painter Franz Joachim Beich*, 1744, drawing by J.G. Bergmüller, mezzotint by Johann Gottfried Haid. International Museum of Photography at George Eastman House, Rochester, New York.

PLATE 6

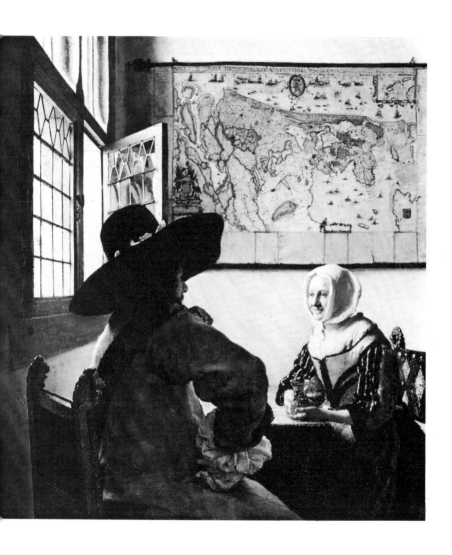

Jan Vermeer, *Soldier and Laughing Girl*, c. 1657.
The Frick Collection, New York (titled *Officer and Laughing Girl*).

PLATE 7

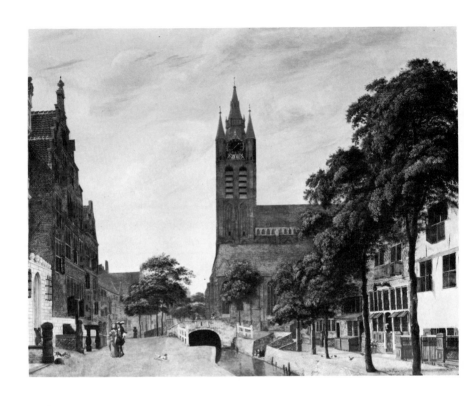

Jan van der Heyden, (1637-1712), *View of Delft.*
© 1983, Founders Society, Detroit Institute of Arts, European Painting, (gift of
Mr. and Mrs. Edgar B. Whitcomb).

PLATE 8

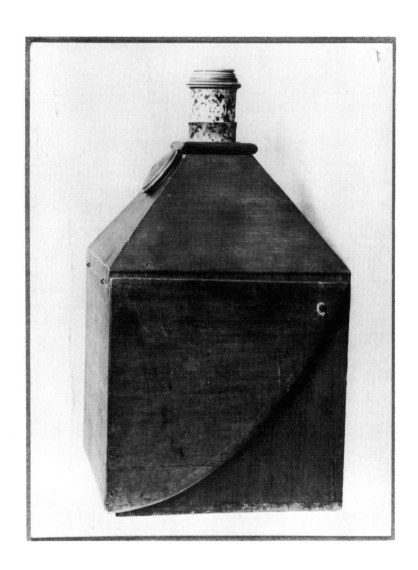

Canaletto's (Giovanni Antonio Canal, 1697-1768), *Camera Obscura.*

PLATE 9

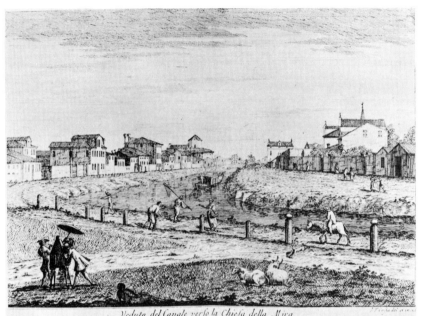

Giovanni Francesco Costa, *Veduta del Canale verso la Chiesa della Mira*, from *Delle Delizie del Fiume Brenta* (Vol. I, Pl. XXXIX), 1750.

PLATE 10

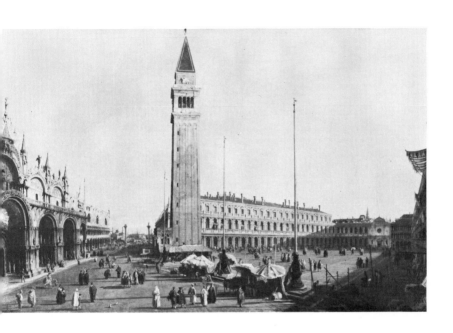

Canaletto, (Giovanni Antonio Canal, 1697-1768), *Piazza San Marco,* n.d.
Wadsworth Atheneum, Hartford, Connecticut.

PLATE 11

Jean Etienne Liotard (1702-1789), *Self-Portrait with Landscape near Geneva*.
Rijksmuseum, Amsterdam.

PLATE 12

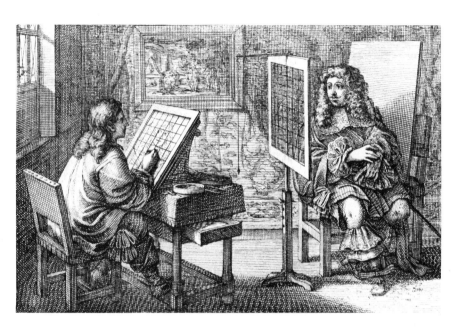

Abraham Bosse, *Un dessinateur faisant au carreau le portrait d'un seigneur,* from *Divers manières de dessiner et de peindre,* 1667 (?).
The Metropolitan Museum of Art, New York.

PLATE 13

Fig. I.

Christopher Wren, *Machine à dessiner*, from *Philosophical Transaction* (IV., March 1669, London 1670).
John Hay Library, Providence, Rhode Island.

PLATE 14

FIG. 2.

FIG. 3.

FIG. 1.

Carl Schmalcalder, *Diagram of "Profile Machine" on his patent application,*
1806.

PLATE 15

Christen Købke, *Portrait of the Landscape Painter F. Sødring*, 1832.
Hirschprung, Copenhagen.

PLATE 16

Jurriaen Andriessen, *Artist with Camera Obscura*, c. 1810.
Rijksprentenkabinet, Amsterdam.

PLATE 17

George Cruikshank, *Sun Drawing*, from *Photographic Phenomena, or the New School of Portrait-Painting*, London, 1841.

PLATE 18

John Constable, *Elm Tree*, c. 1821.
Victoria and Albert Museum, London.

PLATE 19

Ferdinand Georg Waldmüller, *Landscape*, 1834.
Österreichische Galerie, Vienna.

PLATE 20

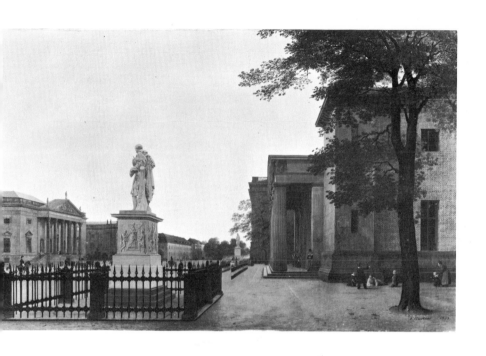

Eduard Gaertner, *New Guardhouse in Berlin*, 1833.
Nationalgalerie, Staatliche Museen Preussischer Kulturbesitz, Berlin (West).

PLATE 21

Johann Erdmann Hummel, *Das Schleifen der Granitschale*, b. 1830–1832.
Nationalgalerie, Staatliche Museen Preussischer Kulturbesitz, Berlin (West).

PLATE 22

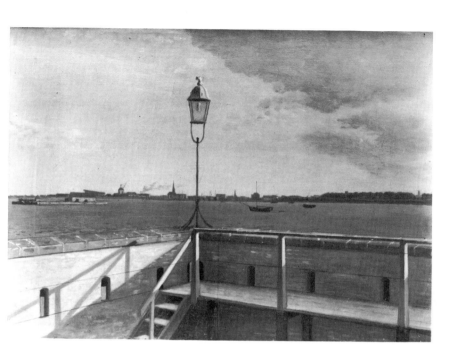

Wilhelm Eckersberg, *View from the Three Crowns Battery Towards Copenhagen*, 1836.
Hirschsprung Collection, Copenhagen.

PLATE 23

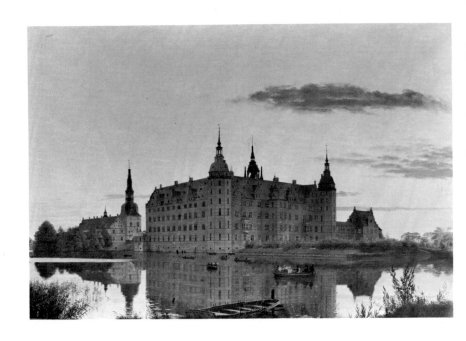

Christen Købke, *Castle of Frederiksborg*, 1835.
Hirschsprung Collection, Copenhagen.

PLATE 24

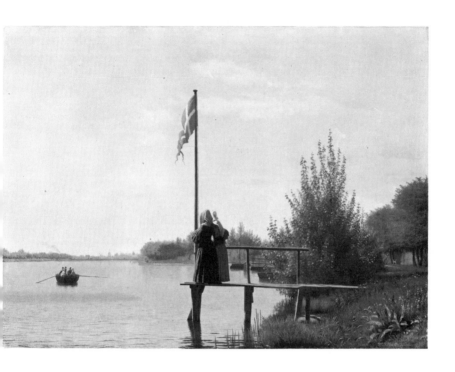

Christen Købke, *Lakeside near Dosseringen*, 1838.
Statens Museum for Kunst, Copenhagen.

PLATE 25

Jean Baptiste Camille Corot, *Factory and Mansion of M. Henri at Soissons*, 1833. Philadelphia Museum of Art, (the W.P. Wilstach Collection).

PLATE 26

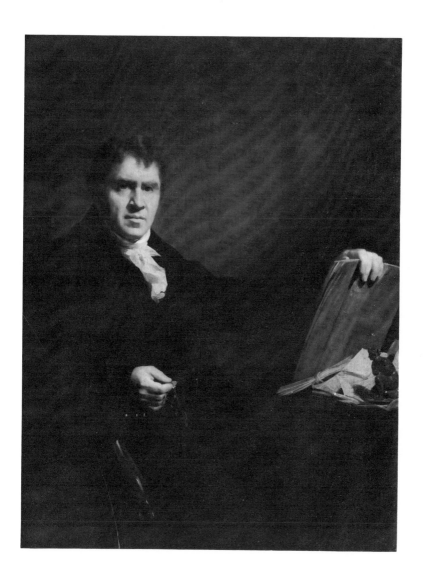

Sir Henry Raeburn, *John Clerk, Lord Eldin*, c. 1790.
Scottish National Portrait Gallery, Edinburg.

PLATE 27

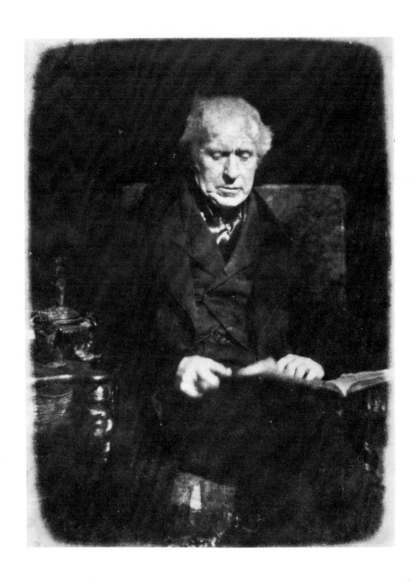

David Octavius Hill and Robert Adamson, *Sir David Brewster,* b. 1843–1847.
National Portrait Gallery, London.

PLATE 28

Nadar, *"Painting Offering to Photography a Place in the Exhibition of Fine Arts,"* wood engraving after original cartoon, Paris, 1859.

PLATE 29

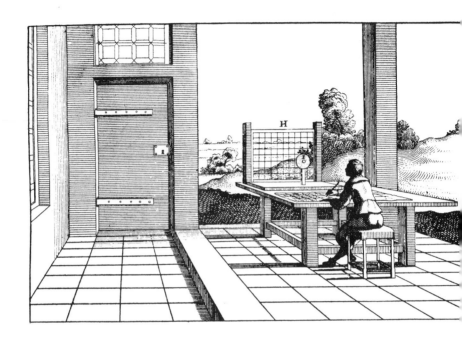

"Machine à Dessiner," engraving from Jean Dubreuil *La Perspective practique,*
Paris, 1663.

PLATE 30

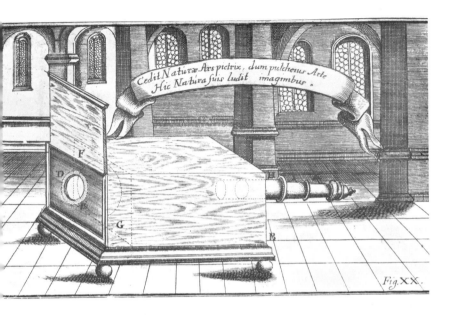

Portable *Camera Obscura*, from Johannes Zahn, *Oculus artificialis*, 1685.

PLATE 31

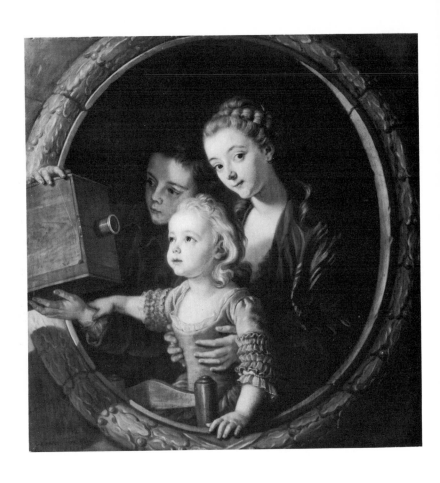

Charles-Amédée Philippe van Loo, *The Magic Lantern*, 1764.
National Gallery of Art, Washington, D.C., (gift of Mrs. Robert W. Schulle).

PLATE 32

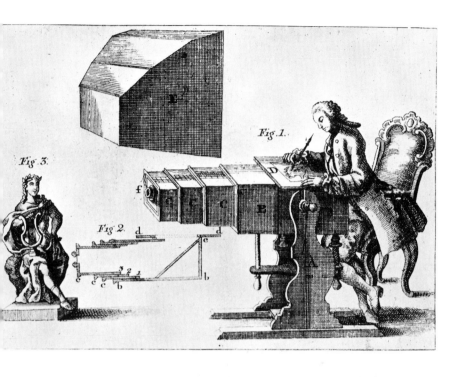

Drawing with the help of a Camera Obscura, engraving from G.F. Brander, *Beschreibung dreyer Camerae Obscurae*, Augsburg, 1769.

PLATE 33

André Gill (?), *Hector Berlioz*, n.d.
Museé National du Château de Versailles.

PLATE 34

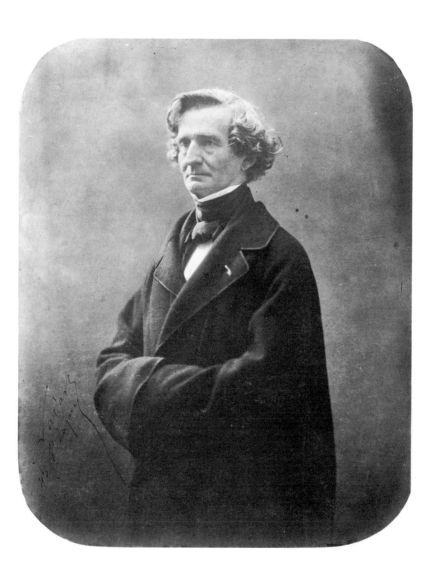

Nadar, *Hector Berlioz*, 1859.
Société française de photographie, Paris.

PLATE 35

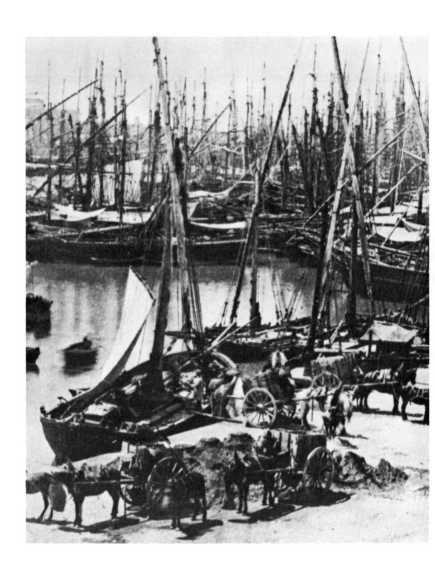

Adolphe Braun, *Harbor of Marseilles,* c. 1860.
Collection unknown.

PLATE 36

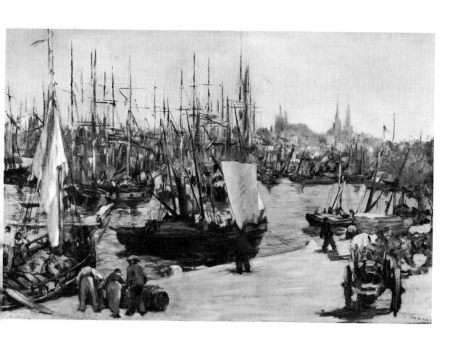

Edouard Manet, *Harbor of Bordeaux*, 1871.
Formerly collection Paul Rosenberg & Co., New York.

PLATE 37

André Adolphe-Eugène Disdéri, *Prince and Princess Metternich*, 1860.
Collection, Const. Danhelovsky, Wien.

PLATE 38

Edgar Degas, *Portrait of a Woman*, c. 1875.
National Gallery, London, (titled *Princess Metternich*).

PLATE 39

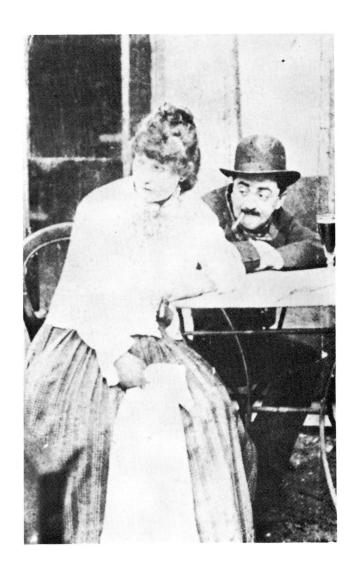

Paul Sescau, *A La Mie*, c. 1890.
Collection unknown.

PLATE 40

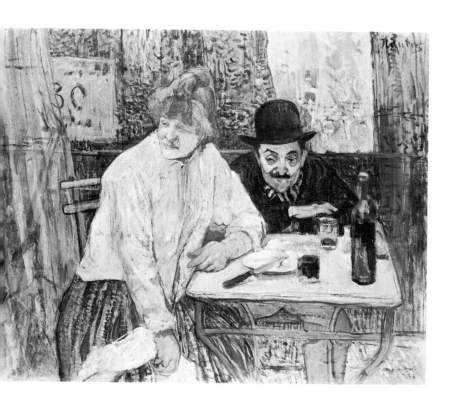

Henri de Toulouse-Lautrec, *A La Mie*, 1891.
Museum of Fine Arts, Boston, Massachusetts.

PLATE 41

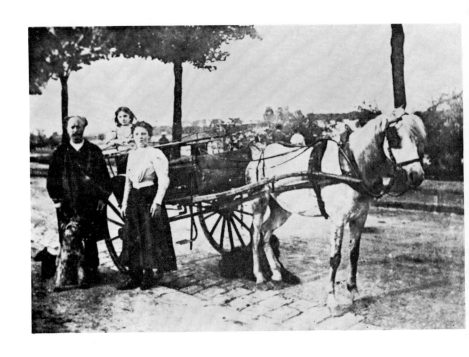

The Cart of Père Juniet, c. 1906.
Collection unknown.

PLATE 42

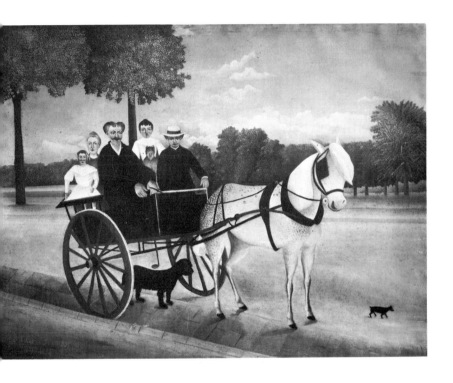

Henri Rousseau, *The Cart of Père Juniet*, 1908.
Collection, Mme. Paul Guillaume, Paris.

PLATE 43

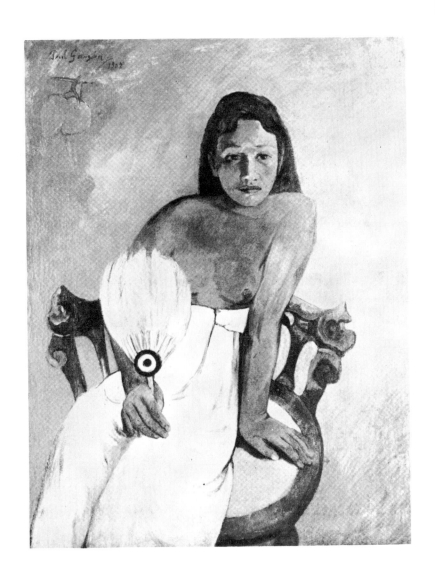

Paul Gauguin, *Woman with Fan*, 1902.
Folkwang Museum, Essen.

PLATE 44

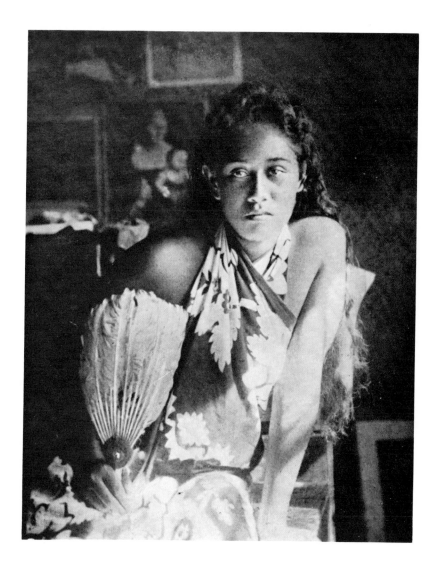

Wife of Gauguin's Cook in Atuana, Marquesas Islands, 1902.
Collection unknown.

PLATE 45

Samuel van Hoogstraten, etching from *Inleyding tot de Hooge Schoole der Schilderkonst*, Rotterdam, 1678, Book VII. p. 260.
The Metropolitan Museum of Art, New York. (Whittelsey Fund).

PLATE 46

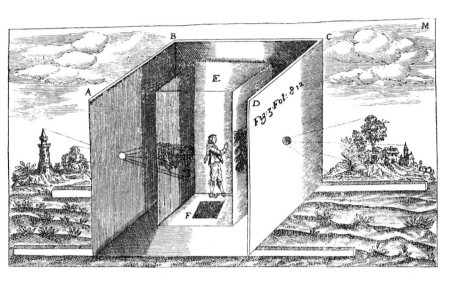

Camera Obscura, engraving from Athanasius Kircher, *Ars Magna Lucis et Umbrae,* Amsterdam, 1671, pl. p. 709.
The Museum of Modern Art, New York.

PLATE 47

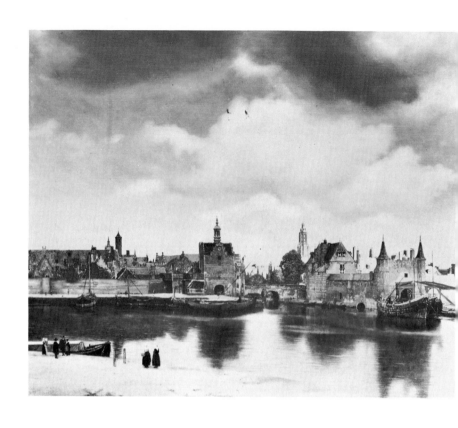

Jan Vermeer (1632-1675), *View of Delft*, n.d.
Mauritshuis, The Hague.

PLATE 48

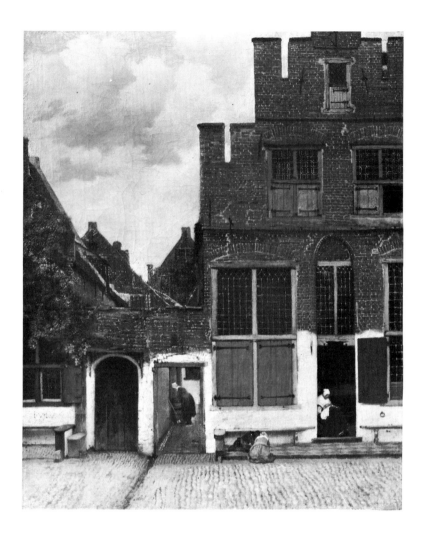

Jan Vermeer (1632-1675), *Street in Delft,* n.d.
Rijksmuseum, Amsterdam.

PLATE 49

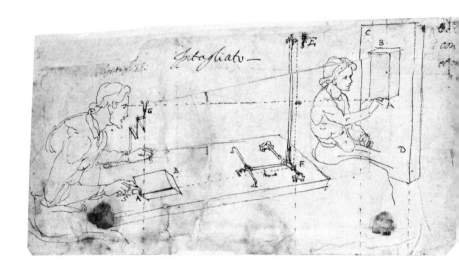

Two Men with a Perspective Machine, North Italian, second half of 16th century, pen drawing.
British Museum, London.

PLATE 50

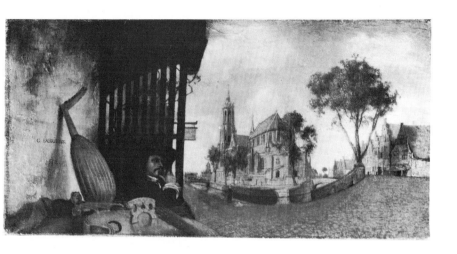

Carel Fabritius, *A View of Delft, with a musical instrument seller's stall*, 1652.
National Gallery, London.

PLATE 51

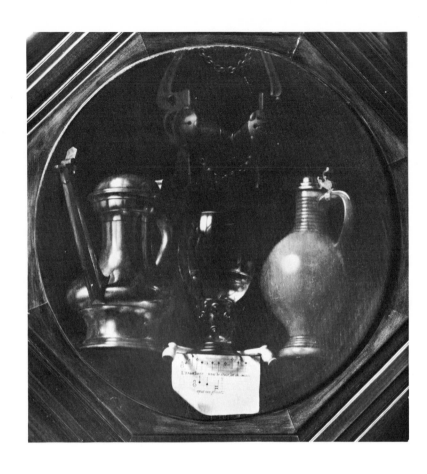

Johannes Torrentius, *Still Life*, 1614.
Rijksmuseum, Amsterdam.

PLATE 52

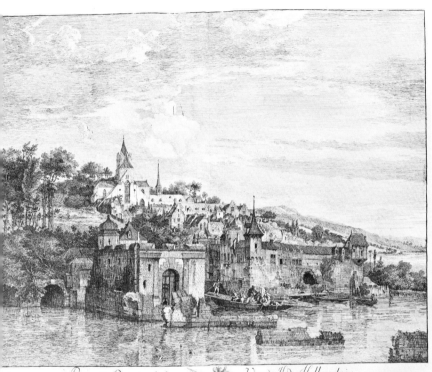

Bernado Bellotto, *Landscape,* etching after a lost painting by Jan van der Heyden,
b. 1756–1763. De Vesme 34.
The Metropolitan Museum of Art, New York. (Dick fund, 1926).

PLATE 53

Honoré Daumier, *Portrait of Alexander Dumas, père,* n.d.
Formerly collection Birger Christenson (1926).

PLATE 54

Honoré Daumier, *Portrait of Hippolyte Lavoignat,* c. 1860.
National Gallery of Art, Washington, D.C. (Chester Dale Collection) (attributed
to follower of Daumier).

PLATE 55

Honoré Daumier, *Portrait of Jules Michelet*, c. 1868.
Stadtkasse, Mannheim, (attributed to André Gill).

PLATE 56

Unknown Photographer, *Portrait of Jules Michelet,* c. 1860.
International Museum of Photography at George Eastman House, Rochester,
New York (attributed to Nadar).

PLATE 57

André Gill (?), *Portrait of Henri Rochefort*, c. 1875.
Formerly collection Richard Goetz, Paris.

PLATE 58

André Adolphe Eugène Disdéri, *Portrait of Henri Rochefort,* c. 1870 (photograph here reproduced in reverse).
Bibliothèque Nationale, Paris.

PLATE 59

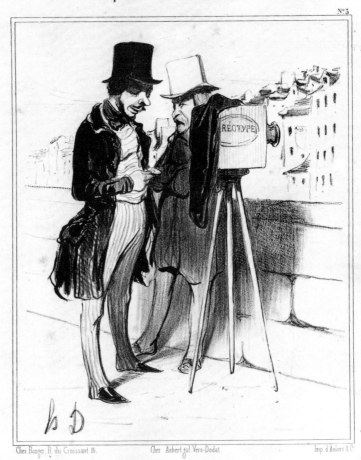

Honoré Daumier, *"La Patience est la vertu des ânes,"* lithograph, *Charivari*, July 2, 1840, L.D. 805.

PLATE 60

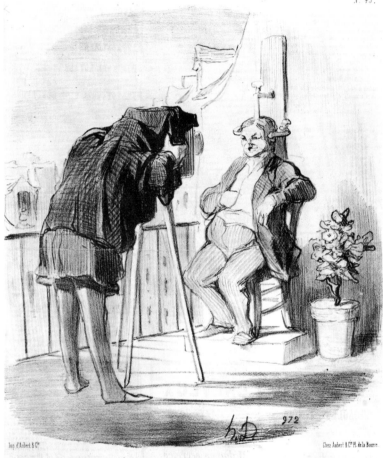

Honoré Daumier, *"Position réputée la plus commode pour avoir un joli portrait au Daguerréotype,"* lithograph, *Charivari*, July 24, 1847, L.D. 1525.

PLATE 61

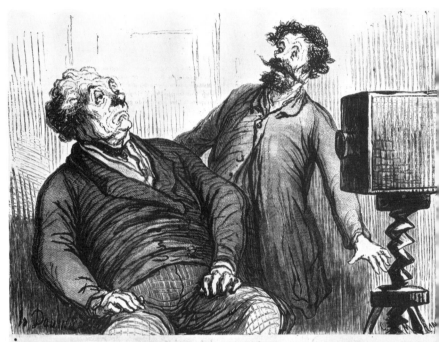

Photographes et photographiés. (Dessin de M. Daumier.)

Charles Maurand after Honoré Daumier, *"Photographes et photographiés,"* wood engraving from *Le Monde Illustré*, March 29, 1862, Bouvy 927.

PLATE 62

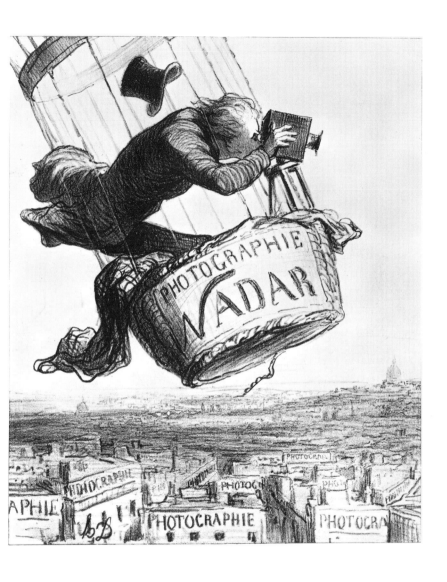

Honoré Daumier, *"Nadar élevant la photographie à la hauteur de l'Art,"* lithograph, 1862.

PLATE 63

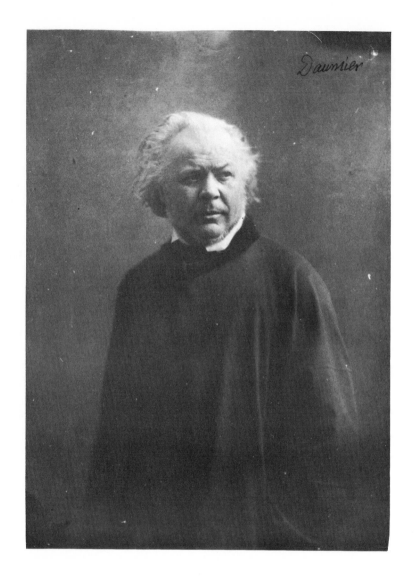

Nadar, *Portrait of Honoré Daumier*, 1859.
Collection, Philip Hofer, Cambridge, Massachusetts.

PLATE 64

ON PHOTOGRAPHY
PART I

TO PHOTOGRAPH CAN be more than to merely release a mechanical device, and a photograph can be more than identity with a limited section of the visual world. If this were not the case, as a superficial or antagonistic approach to this unique function often proclaims, then any differentiation would be caused only by the apparatus or the camera and the final pictorial result would be merely a facsimile. But we do know that this is not the case, that innumerable pictures taken under identical optical conditions would never yield absolutely identical results. We also know that a photographic rendition has never attained or even seriously attempted to attain such a degree of identity with the three-dimensional subject that a differentiation between model and rendition would become practically impossible. From this fact we may draw the following conclusions: First, any degree of quality, from highest perfection to complete insufficiency, is still dependent on one factor lying beyond the camera and beyond the visible environment, and this factor has a decisive impact on the result. Secondly, to photograph is more than to reproduce; it is to transform. Since mere reproduction does not permit any variations, while trans-

formation is open to innumerable variations, the photographic activity requires rational and emotional organization in order to eliminate disorder and, as much as possible, accident, and at the same time to imbue the final creation with the utmost artistic significance. To be sure, the machine would fulfill its task even if no spiritual force were behind it, but the result would be limited to a unique, unalterable and foreseeable image within the realm of myriad possible variations. But even then the machine would transform and not duplicate reality. In other words it would produce an abstraction, since it is incapable of anything else even if it were made to function completely by itself without selective guidance and superior authority. Through these properties peculiar only to photography, its method of producing pictures is unique and thus nearly impossible to compare with other media. Somewhere between inert machine and manual activity—but certainly not precisely half way between—the photograph reflects features of both the passive machine on the one hand and the creative mind on the other, though not in equal measure. For the impact of the mind is so far-reaching that any quality, as well as any lack of quality, resulting from the photographer's activity, is bound to point not only at the apparatus, but also at the person handling it and imposing his will upon it. The photographer bears the responsibility for the achievement because he is the one who not only manipulates his mechanically functioning medium but also determines the time and the place of his photographic procedure. In this way the camera is involved in a spiritual act of which a merely mechanically functioning contrivance would be devoid. Or, to make it perhaps clearer: Let us imagine a machine built one hundred years ago being reactivated today. Its present-day products should be identical with those of one hundred years ago, for they are bound to be the same because all parts of the machine are still performing the same functions, because the procedure, which was exactly determined, has remained unchanged. Daguerre's camera handled by a contemporary operator could theoretically, but would not necessarily, produce the same pictures as Daguerre did. Yet, actually an experiment of this kind would prove that in spite of his endeavors he would not succeed for present-day man uses an instrument

of the past differently. Even if all presuppositions and conditions had remained the same, the photograph of one hundred years ago and the photograph of today would never equal each other because of the fact that not a lifeless mechanism, but a living organism operates the camera and exercises his will through it. Man's domination is to be felt even when the mediating process functions, not in the shortest and most direct way, but when a mechanical instrument stands between inner and outer world, between creative conception and a formative will on the one hand and the visible world on the other. It is not the creative conception, therefore, but the creative possibilities which are limited. The photographer participates in the former, but finds himself restricted in the latter. The camera may be compared to a funnel through which any liquid from heaven or earth may pass, but always following the same path from lens to negative. The photographer, however, is able to aim with this axis in any possible direction. By making his decision as to the direction within this endless range and scope he performs the most essential and important part of his creative act. Therefore, a photograph taken in the days of Daguerre or Hill and Adamson is bound to reflect a mode of representation different from ours. Nature has not changed and the camera has not changed enough to explain this phenomenon, but what has changed is man's outlook and his approach towards the world. Therefore he also gives another direction to the instrument in his hands. This change is two-fold: expressing itself in his aiming at new things and in finding new aims at old things. To be more explicit: The photographer truly rooted in his time will take photographs of things which are new and did not exist before or of things which may have existed before, but were not considered worthy of representation or which could not be photographed for technical reasons. Or he will photograph things which have always belonged to the representational realm of photography in such a different and such a new way that we learn to see and understand these things anew. In this twofold way photography manifests itself as a valid expression of its time and at the same time banishes the danger of a conflict with painting which has existed ever since photography had been invented and which is bound to exist

forever.... Photography is not condemned to follow in the footsteps of painting, nor destined to be a hybrid between painting and a mechanical process not belonging to either. On the contrary, within the limitations of the medium no boundaries are set to the imaginative and creative will of the photographer. He always remains dependent, however, on the subject.... His motive must be present and remain present until the negative has been exposed. The photographer acts as an artist before the camera acts and after the camera has acted: he searches for and discovers the subject; he explores the most rewarding angle and light and he cuts and prints the result.... Even the most beautiful and most perfect photograph will always contain the strange and incomparable elements of arrested life by which this process is distinguished from painting ... and by which at the same time photography assumes the legitimate right to a place in its own particular sphere in the wide realm of art.

—From "On Photography." Unpublished typescript (n.d.), Heinrich Schwarz Estate (New York, N. Y.).

ON PHOTOGRAPHY
PART II

THE GREATER THE distance by which we are sep-
arated from the evolution of art life in the 19th century,
the higher the standpoint (vantage point) from which we are
able to gain a clear and comprehensive view of the entire cul-
ture of the century, the stranger does it seem that our art critics
could, until now, have failed to appreciate the great technical
and physical achievements mankind owes to that period. Only
in the immediate past and the present day have we been gradu-
ally realizing how necessary it is to consider and investigate the
influence those achievements had on the creative forces of art
at that time. At no other period—not even during the Renais-
sance—was artistic evolution so closely linked to the scientific.
But the present time only has taken into account, and drawn
conclusions from, these close relations and the very essential
changes resulting from them, changes that have given rise to a
new aspect of the visible world, thereby moving our immediate
past and shaping its features.

We have grown to fully understand the causes why a scien-
tifically new aspect of life, founded on antiquarian science, and
called classicist, took the place of Baroque art with its
metaphysical leaning. But the way leading thence to the *his-
torism* and *realism* of the new century still lies in a certain dark-
ness. We can, however, throw light on this change by recogniz-
ing that at no time were technical and physical aims and
achievements more important for artistic development.

Thus we gain a new basis for the judging of landscape paint-
ing at the turning of the 18th and 19th centuries by taking into
account contemporary geographical and scientific researches;
portrait painting and portrait sculpture will be better under-
stood by a consideration of medico-physiognomical realiza-
tions and historical painting cannot be viewed apart from the
historical researches of the 19th century. For 19th-century art
results from associations of a new scientific penetration of the
world-aspect. Long before such changes took place, parallel
intellectual tendencies made themselves felt. They gradually
condensed and after a time of apparently desultory searching
they found their way towards realization. In 1839, the painter
Daguerre was able to announce to the world that his long at-
tempts had, at last, been successful, and that he had found a
means to fix the transient image in the *camera obscura*.
Thereby was realized an idea that may be traced back as far as
the late Middle Ages, an idea that, suddenly and unexpectedly
rising again in the 18th century into greater clearness and pre-
cision, fundamentally changes the artist's view of the visible
world. The year of Daguerre's invention, as in that of every im-
portant invention, meant nothing but the moment when the
acquired knowledge had become so convincing and the need of
realizing this invention so pressing that it could no longer be
delayed by any difficulties or obstacles. This is proved by the
fact that an invention is hardly ever a phenomenon temporally
or locally isolated, and that prior to an inventor's success are
numerous forerunners who have consciously attempted to
tread similar paths without, however, attaining the desired
goal. The endeavors of these forerunners, who had as it were
started too early, were as yet doomed to fail. For the soil for
new knowledge is prepared by the concentration of all forces
that make an invention historically imperative, that allow us to
recognize a personal achievement as a superpersonal occur-
rence and the inventor himself as the instrument of an indi-
vidual will soon to be that of the community.

It is in the physical (scientific) knowledge acquired in the
18th century and in the new social order prepared for mankind
by the French Revolution that we must look for causes of the
recast in the aesthetic notions and ideals of the social class that

was to determine the coming century. New forms of life are struggling for expression and find new means for doing so. The burgher, to whom the great social solution of the late 18th century had brought liberation from long worn fetters, became conscious of his personal dignity. His outlook on life is different from that of the dominating class of the 18th century. His view of life has diminished but at the same time increased. It has diminished through being limited to the visible world; it has increased through extension, within the visible world, of the spheres of observation and the stratum of social identity henceforth called to take part in cultural life. To this newly awakened vitality of a social class, grown strong in its self-confidence, corresponds a strong determination to give pictorial expression to its new position and to declare and manifest the new vitality. The old means of pictorial expression, however, are not sufficient for this; they are too exclusive owing to their technical complexities. The new time puts forward new claims. The mass of people that have taken over the old privileges and ambitions stands on a broader basis than before. The situation resembles that of the close of the Middle Ages.

In the Middle Ages, new means of expression were brought about by the shifting of social strata and by the interests of man being turned upon objects that no longer lay within the religious, the metaphysical, sphere. The craving for acquiring and presenting knowledge had then become so urgent among the broad masses of the people that the old means of expression and understanding no longer sufficed. New paths were to be taken in order to satisfy the increased desire for a pictorial and written presentation of the new conditions. Woodcutting, engraving and printing, which resulted from this desire almost simultaneously, were able to satisfy the need for four centuries; they became insufficient only when a new social upheaval summoned more and more human strata to an active part in cultural life. The need of granting this active part to ever widening circles produced—at the end of the 18th century—a new graphic means, lithography, a means that for the first time after four centuries provided an absolutely novel possibility of graphic expression. Lithography was founded on an equally novel technique, basically different from all older graphic

methods. At the same time, there cropped up all kinds of attempts to increase typographic efficiency and, by mechanistic procedures such as stenotypy, there opened out new possibilities for the act of printing by which written communication was to become more rapid and rational. But, after a few decades, lithography had to give up its place to photography, a new method of pictorial presentation and reproduction that far outdid the seemingly unsurpassable merits of lithography as to production and reproduction.... The evolution of graphic methods is the same as that of all the other functions of life; starting from organic it becomes inorganic only to end in pure mechanics. It is the same in music and writing. Handwriting makes way for printing and the mechanical phase is represented by the typewriter or the typesetting machine. The invention of photography, however, is not only the inevitable result of a rationalization occasioned by the shifting of social strata; it is—and this is its real meaning for us—the symptom and the cause of a new aspect of the visible world, a new attitude considered to be the center of all artistic endeavors. This new, realistically bent, attitude that was to rule the coming century had been prepared already by the closing 18th century. But new pictorial phenomena were comparatively few and were soon merged again in the Baroque art which, although its days were past, continued to make itself felt throughout the classicistic period, and in the classic art itself. New pictorial phenomena grew really strong only in the second decade of the 19th century, taking a lead with elementary force. At the same time, when Niépce and Daguerre in France and Talbot in England attempted to gain a lasting record of the natural image in the *camera obscura,* European painting conquered the last Baroque and classicistic stragglers. In the ten years between 1785 and 1795 ... were born the masters that were to determine European painting in the first half of the 19th century: Corot in France, Blechen in Germany, Waldmüller in Austria. In the same decade lies the birthyear of Daguerre, whose invention absolutely realized the artistic will of that generation of painters, exceeding everything hitherto achievable by painting or drawing. From the very first day of the announcement of that invention the question became urgent as to whether this

new means of presentation could be ranged within the old art categories, but as yet no generally valid and recognized answer has been given. The experiences obtained in physical science were pervaded with the artistic convictions of the time, and brought about a new style whose evolutionary nature will bear comparison with the changeover wrought upon the quattrocento by the newly acquired knowledge of perspective. These experiences created in photography a medium that was able to draw the forces for the creation of pictorial presentation from the command of physical and chemical knowledge. From the purposeful working together of these two sciences developed a new creative method, opposing in an almost uncannily drastic way to the 18th century's irrationalism and religious-transcendental world, the supreme law of reality and objectivity. The knowledge of natural phenomena and processes became the great problem for art and science in the 19th century. Both, art and science, seek to attain the same goal by different ways, the goal of interpreting the natural phenomena and processes and making them serve their ends. The new visive processes of the period of *realism,* the endeavors to fix in the optic situation of the creative hour only that which is visible and actual and to get the better of subjective boundlessness by closer approximation to nature, become the foremost tasks of the artistic will. The road of scientific research is mapped out once the forces dormant in nature are recognized and turned to account. Art and science wish to penetrate into nature's secrets by an objective recording of visible phenomena, and the cooperation of the artistic will and the scientific thirst for knowledge promotes the invention of photography as a new means for visualizing and reproducing visual phenomena. This means, therefore, takes up an entirely novel position between creative and technical art, and the terminology handed down to us from the aesthetics of the 18th century must needs fail in dealing with it. Many symptoms point out to us how, at that time, artistic and scientific endeavors vied with one another, how strong was the inward readiness of man to photograph before ever photography was invented. Artists made use of the *camera lucida* as a help for rendering their drawings as true to nature as possible long before photography was invented; the

silhouette made use of light for creating the image; sculptors in the early 19th century made their effigies from casts as Renaissance artists also had habitually done and painters were the innovators in photography. These facts alone make it imperative for art history to take photography into consideration. There are other reasons besides. For the history of art, the problem of photography from the very first has been divided into two aspects: its importance as an independent creative means of expression and its artistic influence on pictorial conceptions. The first, so far, has hardly interested art history, the second not at all, and this omission becomes the more inconceivable the more we begin to recognize the fatal influence of photography on 19th-century portrait and landscape painting, on the visive process of Impressionism, or on the techniques of reproduction. The more we recognize such influences the clearer we realize that the year, 1839, makes probably the deepest notch in the course of the last centuries. . . . And now we make the astonishing discovery that the main questions laid before aesthetics and art history had been already put on the very day of the announcement of photography's invention; that the bewilderment at this invention, which we can hardly realize, had not yet subsided when artists and scientists were wondering whether this new means were a fully adequate means of expression, whether it were an artistic means of expression at all, and whether its access to old artistic categories should be denied or granted.

The absolute novelty of the invention of photography may be recognized by the perplexity and the conflicts of contemporary judgments. Lithography had called forth similar perplexing and contradictory statements, but after a very short time the unbelievers were disproved and the skeptics convinced. Not so with photography. Questions about photography were affirmed, were denied and were affirmed again, according to the attitudes of people towards the visible world. At a time when Taine could say, "I will reproduce things as they are, or as they would be under the supposition that I did not exist," the majority of artists had to profess themselves followers of photography without any reserve; at that time the enthusiasm of Delaroche's statement, "From this day on, painting is

dead," becomes comprehensible. Painting was not dead, least of all in France where those eccentric words were pronounced, but one of its most critical turning points was reached. On the contrary, only a few years later, painting was to produce interpretations which could not recognize in the lens of the camera a perfect compensation for the human eye and in the photographic apparatus a substitute for contemporary critics. Impressionism, denying the solid shape and the physical existence of things and explaining the environment as changing individual visions of our conscience, was bound to reject photography as an artistic means of expression, photography being a means of achieving an apparently absolute and impartial record. Impressionism rejected photography, although the growth of its style and its perceptions owed more to photography in several respects than have been divined until today. But, perhaps, it is just this very dependence on, or this relation between, the visual processes of Impressionism and instantaneous photography that explains the aversion.... We are now able to recognize that the expressive forces of photography and painting are subject to permanent changes, especially dependent on the attitude of man toward the visible world, and that the effects between both— repelling and attracting in incessant change—are inevitable and could never be eliminated.... It is necessary to ask ourselves what photography has in common with the activity of a painter or draftsman and what separates them from this manner of representation; in what way features are inherent to photography, which are not in common with painting and other graphic arts, and which therefore form its characteristics.

Photography does not give a lifelike reproduction, but an abstraction, a transformation; it endeavors with its means just as painting—certainly in a quite different way—to pictorially define a demarcation of multiplicity, to offer a convincing, purposeful organization of chaos.... What photography is able to give is no facsimile, no *copie trompeuse* of a physical object, but always an adequate transformation, an abstraction, but never a lifelike reproduction. For photography transforms, in its way as does painting, the physically tangible, the object of three dimensions into a plane of two dimensions. Just as other

graphic arts, photography typically renders the colored multi-
plicity of subjects as a sequence of values ranging from deepest
shades to clearest lights ... a sequence which is an absolute
continuity, as it may be produced by light, but never by manual
technique, not even by mezzotint or lithography. Painting and
photography have another feature in common in that both face
the visible world with the inner readiness to limit this visible
world and to change it in some way. But for painting, the visi-
ble world is not its exclusive and most important object ... in-
finite variations are possible for painting beyond reality: the re-
ligious, the symbolical, even the objectless painting. ... Paint-
ing, nevertheless, is boundless with regard to space and time;
its activity, independent in many ways from reality and the
present, is therefore an act of creation, whereas photography is
always subject to reality and the present. Only that which
theoretically the human eye is able to see, can photography re-
produce; what lies beyond the visible and tangible, what eye
and lens cannot observe, that is, all not existing in time and
space, cannot be reproduced by photography and is reserved to
the creative action of the painter. Wherein, then, can consist
the artistic performance of the photographer? And is there
under these restrictions still a space left, within which an artis-
tic will is able to display and to reveal itself? With these ques-
tions we come to the fundamental difference between the artis-
tic activities of the photographer and those of the painter. The
photographer participates in the artistic insofar as he, too,
needs pictorial intuition. In that "critical supposition," which
could be called "creative perception," the photographer is con-
nected with the painter ... He needs a point of view as well as
the creative artist; he has to observe and this observation has to
include a higher conception, a regulating force and a shaping
will. The more of that really artistic perception a photographer
owns, the more of artistic nature will his work contain. But all
does not lie within the scope of that pictorial perception, for
not only are the selection of the subject and the cutting, not
only are the foresight of ultimate effects and the elimination of
unpremeditated chance, bases for creative intuition and picto-
rial perception, but the photographer can find his object to a
certain extent uncreated. He may have to create or form it ac-

cording to his own will. He does not create his object in reality
as does the painter, but he creates, before the camera begins to
function, the irrevocably ultimate aesthetic form. He carries
the notion of the shape of an object in himself and he takes the
object destined for that form, giving it a certain position or
moving it into a certain situation of light, in a certain relation
to space.... The photographer's artistic performance is thus
displayed in pre-photographic and in post-photographic ac-
tion; in the preparation for real photographic action and in the
reproduction of the photograph. The painter recreates his ob-
ject from beginning to end ... through his activity, through his
painting. The photographer, it is true, changes his object, too,
by his photographic action ... he gives the convincing shape,
most clearly adequate to his perception, before, and he fixes
this shape in a mechanistic way.... Whereas the painter re-
mains creative from first to last, the creative activity of the pho-
tographer is confined and limited; whereas the artistic action
of the painter is not interrupted, the artistic action of the pho-
tographer breaks off in the moment in which the apparatus is
to fix and make visible its effect. This is an absolutely novel
method of artistic perception and production, a method which
cannot be compared with any newer or older graphic tech-
nique ... The mediatizing of the original artistic feeling and
organization is made by a mechanistic apparatus which acts
by a purposeful cooperation of physical and chemical
phenomena. The visualization of an image does not only result
from human forces, but also from forces of nature lying out-
side human activity and hardly influenced by it. Here we are
again faced with the question: If the fixation of artistic percep-
tion, that is, the decisive procedure of the transformation is not
produced by a living organism, but by a dead apparatus, is it
then possible for the artistic will to keep its force and to remain
visible and perceptible, even in the final (ultimate) effect, in the
photograph itself? Or is this artistic will destroyed and stopped
by the mediatizing of the apparatus, or is it diminished and
only imperfectly reproduced? We are rather inclined to believe
the latter, for the chemical and physical work of the camera is,
after the performance of the pre-photographic functions, forci-
ble and unchangeable—whereas the work of the painter is

never detached from the artistic will— and yet the result will be an artistic one on the understanding that a man with artistic feeling and creative forces be acting and because the essential artistic achievement is fulfilled in the photographic action and not in the realizing action of the apparatus.

If taking a photograph were really no more than a mechanistic process in which the human spirit and creative will have no part, all results produced under the same technical and optical conditions must be quite identical.... But the still rather imperfect knowledge of the history of artistic photography teaches us that the means of the photographic apparatus is on no account so dead and mechanistic that it would abolish and level all individual perception; and it teaches us that the individual intensity of observing and experiencing the facts of the visible world is able to transform even the dead photographic apparatus into an instrument of astonishing sensitivity. Each photographic document points in some way to the man standing behind the camera; all depends on him when all is said and done, and every quality produced is always his work. The impersonality and objectivity apparently so adequate to the mechanistic is by no means warranted by use of the mechanistic process. And that especially so because an artistic process goes before the mechanistic one, a process which the camera is able to preserve and make visible ...

—From an untitled lecture typescript (n.d.),
Heinrich Schwarz Estate (New York, N. Y.).

ON PHOTOGRAPHY
PART III

19TH-CENTURY ART grows out of associations created by the scientific view of life. Explorations and discoveries in geography and physics help to form the foundation of its landscape painting, and its revival of earlier styles has its roots in the retrospective spirit of historical research. Thus 19th-century art can be understood only by taking into account this association with the scientific endeavors and achievements of the period and of the centuries preceding it. The beginning of the development, however, reaches back to the days of the Renaissance in which the link between science and art took form. This affiliation reaches its peak in the 19th century when the study of optics and the theory of colors coincide with and stimulate new ideas in the world of art. Lacking the great spiritual orientation of earlier times, art gains new impulse from its interrelationship with science. A tremendous enrichment of the thematic store results from this connection, as well as an undeniable impoverishment in spiritual values. Sun and light become the central problem of painting; conquest of the visible world the paramount theme of the time. Scientists turn towards this goal just as the artists do. As a natural consequence of the growth of rationalism, faith in technical progress almost becomes a materialistic religion. "Science is a religion," exclaims Ernest Renan.

Naturalism as an aim, which becomes dominant in the 19th century, appeared as a powerful impulse in the days of the Renaissance. In the field of art it led in the 15th century to the study and application of the rules of perspective accompanied

and followed by the invention and use of mechanical devices. Among them were the *machine pour dessiner* in its various forms, the *camera obscura*, mirrors used as aids, and finally, the contrivances for silhouette and *physionotrace* portraits in the 18th century. Lastly, this aim culminated in the invention of photography in which physics and chemistry unite in order to receive and perpetuate the picture drawn by the sun itself. Mankind's dream of gaining a maximum of inorganic power from the world around him and of reducing human work to a minimum does not stop at the threshold of the domain of representational art. All these efforts concur with the desire to increase pictorial exactness and verisimilitude and to create an image as close to the model in nature as possible. Yet the association between science and art may not always be so apparent, the development not always so readily observable. Nevertheless, to mention but a few examples, the influence of the invention of the microscope on Callot's etchings or Swift's writings, or of the telescope and other optical devices on Dutch painting of the 17th century, is not the less real because hitherto it has hardly been noticed or investigated.... The history of art has avoided this difficult and delicate task, though we are beginning to realize more distinctly that any profound treatment of 19th-century art and that of the art of the last five centuries requires an interpretation that takes into account this aspect of the link between science and art with all its consequences. Photography is but the final culmination of a long development and must not be studied historically as an isolated phenomenon of the 19th and 20th centuries. For the spirit of photography is much older than its history ...

—From "Talk on the Exhibition, 'Great Masters of Early Photography: Calotypes by D. O. Hill and R. Adamson, 1843-1847,' Davison Art Center, Wesleyan University, February 14, 1962." Mimeographed typescript, Heinrich Schwarz Estate (New York, N.Y.).

BEFORE 1839: SYMPTOMS AND TRENDS

O NLY A FEW years— sixteen years to be exact—after the invention of photography in 1839, Nadar, himself a photographer among many other things ... ridiculed the rain of photographers descending upon the world. And very shortly afterwards, exactly one hundred years ago in 1863, Samuel Butler, the English writer, foresaw and predicted the triumph of the machine which in the early days of the Industrial Revolution had begun to conquer and replace the handmade product. "Day by day," Butler wrote, "the machines are gaining ground upon us. Day by day we are becoming more subservient to them; more men are daily bound down as slaves to tend them; more men are daily devoting the energies of their whole lives to the development of mechanical life. The upshot is simply a question of time, but that the time will come when the machines will hold the real supremacy over the world and its inhabitants is what no person of a truly philosophic mind can for a moment question." For us, to whom the Industrial Revolution has become a historic fact, this amazing prophecy of the age of automation which we are now beginning to enter is finding its fulfillment.

Plate 1

Another document which may be fitting to introduce a symposium on photography—or at least a talk on some aspects in

Plate 2

the history of photography—is last year's New Hampshire license plate. It seems to me highly charged with implications of many kinds. It somehow implies that God has created beauty in order to attract and satisfy photographers who would not be disappointed if they should come to New Hampshire with their cameras. Nadar's cartoon and New Hampshire's license plate could be considered landmarks in the history of photography. At least they signify important symptoms in the comparatively short history of photography—covering a mere 125 years—and illustrate the tremendous impact of this means of picture-making. And we can safely state that we have by no means reached the peak and that photography has still a long way to go before it will be relieved by another visual and pictorial method, since nothing lasts forever.

But what I'm expecting and planning to discuss here is not a look into the future of photography, but into its past; or even more than that, into its distant past: the days before photography was invented yet already present. For, like most of the graphic processes capable of producing multiple images or copies, photography too has a long history, reaching far beyond its lexicographic date of invention. Although photography cannot claim Far Eastern ancestry or origin as can the woodcut which had been used in China more than 500 years before it was reinvented in the West, or as can metal engraving which goldsmiths and silversmiths had practiced long before the printing of their incised designs had become a mere second stage of a two-stage operation—engraving and printing— photography too can claim a centuries-old, quasi-clandestine tradition and history.

Only in 1839—or to be exact, as early as 1827—does photography emerge as a full-fledged technique after long and almost continuous development, a development which at certain times appears on the surface and disappears underground at others. Its spirit, however, has been somehow present ever since, to quote Panofsky, "the Renaissance established and unanimously accepted what seems to be the most trivial and actually is the most problematic dogma of aesthetic theory— the dogma that a work of art is the direct and faithful representation of a natural object."

The convention of a fixed viewpoint and the rigid bounds of perspective, linked with and aiming at representations of scientifically valid verisimilitude which the early Renaissance proclaimed as the supreme aim of the visual arts, is clearly demonstrated in the *camera obscura* and the *machine à dessiner*. Both may be considered as among the physical presuppositions for the invention of photography. And the time has come when a new approach towards a history of art would look much more deeply into, and explore more thoroughly, the interdependence of science and art, [no longer treating] them as two antagonistic, incompatible or uncongenial expressions of the human spirit. Even more than that [the time has come] when a history of Western art from the 14th century to the end of the 19th century, that is to say of the wide span of almost 600 years, could be viewed from the viewpoint of photography—photography in the widest sense of the term! For the passion for the mathematically exact copying of nature, clearly manifest in the use of a recording machine, more or less dominated the Western perception for many centuries, until the reaction against this approach made itself felt in the late 19th and early 20th centuries. We have long passed this crucial turning point and for more than half a century have witnessed, first, the struggle for the break with the past and, eventually, the emancipation from and renunciation of the Renaissance's principle aim: the ideal of a three-dimensional illusion and the abstraction of space as it appears framed in a kind of showbox or on a stage distinctly bounded by the picture frame, [well illustrated by a 15th-century painting] in the Walters Art Gallery in Baltimore. *Plate 3*

There is little difference, if any, in the basic concept of Carlo Crivelli's *Annunciation* of 1486, in the National Gallery of *Plate 4* London, and Alfred Sisley's *House of Madame Du Barry*, *Plate 5* painted almost 400 years later in 1873; or to include a photographic example, between *Rue Zachary* by Eugène Atget and Maurice Utrillo's *Puteaux*. New concepts which brought to an end the Renaissance scheme that had grown old have taught us —rather, our fathers and grandfathers—that the basic rules which had dominated the concept of representation for so many centuries and which had almost seemed final and indestructible, were, in spite of the venerable age, just one form of

abstraction, as transitory as any other and by no means the one and only or the most simple and obvious approach. To quote Evelyn Waugh, writing in 1929, "In Lisbon I reflected: it is only since the discovery of photography that perspective has ceased to be an art." Or, an earlier statement by the French-Czech painter, Frank Kupka, who wrote in 1913, "I have come to believe that it is not really the object of art to reproduce a subject photographically. Music is an art of sounds that are not in nature and almost entirely created. Man created writings, the airplane and the locomotive. Why may he not create in painting independently of the forms and colors of the world about him? The public certainly needs to add the action of the optic nerve to those of the olfactory, acoustic and sensory ones. I am still groping in the dark, but I believe I can produce a figure in colors as Bach has done in music."

Photography and its implications have played an important part in bringing this situation about and into clear focus. Yet, for at least two generations or more, photography and illusionistic painting still moved on parallel roads, or on roads which sometimes converged, sometimes diverged, but which at no time in the 19th century considered themselves basically irreconcilable and antithetical forces. This was to happen only towards the end of the 19th century.

The disintegration of the world of the Renaissance and, mind you, of the Middle Ages, became unmistakably manifest with movements such as Cubism and many others—[as in] an example which has nothing to do with Cubism, a landscape by Klee, painted in 1929—the rise of which coincided with the fundamental disintegration of the old political and social orders and the organization of new ones.

Jean Cocteau's often-quoted words, "photography has liberated painting," contains the same truths. But on the other hand it remains questionable whether photography will ever be completely liberated from the inferiority complex of an underprivileged stepbrother and whether a true coexistence of the two fundamentally different media, painting and photography, can become a reality.

In a history of painting or of art in general seen from the point of view of photography, one of the fundamental ques-

tions would be the question of when the inner preparedness for photography arises. In a philosophical essay on photography, published in 1930, the author presents the hypothetical question of how a man of the 11th century, who in some miraculous way had obtained the faculty to take photographic pictures, would have used the medium, and more important, whether he would have used it at all. The [slide shown] is a fragment from the famous *Bayeux Tapestry* [made] in the 11th century around 1080—it is not a tapestry; it is actually an embroidery. This question, whether he would have used it at all, points to the time-dependence of photography or of any other invention; to the fact that a kind of inner preparedness was an essential factor for any new idea, its maturing and realization. In the case of photography, some of this inner preparedness or readiness had already been present when the fixed viewpoint had become the *alpha* and *omega* of the aesthetic credo. For the basic idea of this approach is drastically manifest in the *machine à dessiner* in its numerous forms, in the *camera obscura,* and in the mirror as an implement of the artists' studio. A long list of artists who availed themselves of these and other devices could be enumerated and their works discussed. The list comprises illustrious names and many names of lesser significance, [the latter as shown in this] detail from a mezzotint print done in 1744, [portraying] a little-known German artist [and] his implements, [including] a *camera obscura.* Plate 6

It has almost become common knowledge to connect the name of Vermeer van Delft with the *camera obscura,* and, time permitting, more evidence supporting the theory—which has been accepted and rejected and only very recently, in an article in *The Art Bulletin,* it has been accepted again—could be offered here. As a curiosity, I want to mention that Joseph Pennell, an American etcher and lithographer, was, of all people, the first to express, as early as 1891, the conjecture that Vermeer may have used a mechanical device—he mentioned the wrong one—in painting his picture *A Soldier and Laughing Girl,* which is now in the Frick Collection. But Vermeer was by Plate 7
no means the only Dutch painter [to use a *camera obscura*]. Just one other rather striking example, a painting by Jan van der Heyden, may prove the continuation of this tradition by a Plate 8

Dutch painter whose life span reaches into the 18th century. But, while some of Vermeer's paintings show the blurred effect for which the *camera obscura* may be responsible, this painting shows a different quality of the camera: the precision and luminosity of the photographic document which only an instrument of greater perfection could have achieved.

The 18th century—the last pre-photographic century—becomes the classical age of the *camera obscura*, just as the 15th, 16th, and 17th centuries were the classical centuries of the *machine pour dessiner*. [The two slides on the screen show] *Plate 9* Canaletto's *camera obscura* and an etching by Giovanni Francesco Costa from the beautiful set *Delle Delizie del Fiume* *Plate 10* *Brenta*, published between 1750 and 1762, in which a tent camera is in use in the lower left corner.

We have ample evidence for the wide use of the *camera obscura* in treatises, letters, and other records, but above all in the paintings and prints themselves. The works of the great Venetian *vedutisti* Canaletto and Guardi have been carefully studied in this respect in the recent past, and the documentary and pictorial evidence has been corroborated by the strictest scientific examination. The method has not been applied yet to many artists and their works. It will eventually, however, yield more and sometimes significant and essential evidences. Inci- *Plate 11* dentally, two paintings [by Canaletto]—one in the Wadsworth Atheneum in Hartford, one in the Louvre—show the pictures or images which are composed of two or even more images created in the *camera obscura*.

Without claiming that Jean Etienne Liotard, "*le peintre de la verité*" as he was called or as he even called himself, made use of the *camera obscura* or of any other mechanical device—his writings do not contain any clue—his *Self-Portrait with Land-* *Plate 12* *scape near Geneva*, actually the view from the artist's studio painted between 1765 and 1775, is so unusual in many respects that it would be hard to compare it with any other landscape or self-portrait of the 18th or any other century. And his portraits, which Horace Walpole called "too like to please," often evoke through their astounding veracity and immediacy the appearance of photographic likenesses still several generations away. In passing, however, it should be mentioned that

Liotard also painted the portrait of Count Francesco Algarotti, who was a convinced advocate of the *camera obscura*.

But the 18th century was a century not only of the *camera obscura,* but also the period when the use of the *machine à dessiner* reached its peak. [This slide] is, however, [of] a *reticolato,* as it was called by Leon Battista Alberti, here shown in use by a portrait painter in an engraving by Abraham Bosse, a work of *Plate 13* the 17th century. The devices themselves attained forms and proportions which dwarfed their simple original prototypes. Leon Battista Alberti's *reticolato* or Leonardo de Vinci's *vetro* ... were both popularized through Dürer's well-known woodcuts. Or, to present much less-well-known examples: Egnazio Danti's contrivance, published in his *Due regole della prospettiva* (Roma, 1583), or Christopher Wren's device of *Plate 14* 1669. They were much in fashion, even in the 19th century, and had finally attained such awkward appearances and dimensions that they were ridiculed in cartoons. But this [slide] is not a cartoon; this is actually the illustration of a *machine à dessiner* for which the inventor received a patent in 1806. The *Plate 15* next [slide] is a cartoon which derided the ever-increasing fashion to have one's likeness painted, engraved, etched, lithographed, silhouetted and physionotraced—fields taken over by photography in the 19th century.

Early in the 19th century, another optical device which played a certain role in the prehistory of photography—the *camera lucida*—became popular with artists, and even more with would-be artists and amateurs. Its invention is generally ascribed to the British physicist and chemist William Hyde Wollaston, who took a patent out for this device in 1806. But, at best, we can call it a reinvention since exactly the same device had been clearly described by Johannes Kepler two hundred years earlier in 1611. This particular merit of Kepler's, however, had fallen into almost complete oblivion in the 19th century, so that Wollaston's *camera lucida,* improved by Giovanni Battista Amici and published and described in various scientific papers by both men, could be accepted as Wollaston's invention. In any case, Wollaston gave the device the name *camera lucida,* a term which is still in use. Its importance for the history of photography also lies in the fact that

William Henry Fox Talbot, inventor of the first negative-positive process, availed himself of the *camera lucida* while travelling in Italy in 1833, and that his desire to make the image appearing in the *camera lucida* permanent led him to the discovery of photography. In the second half of the 19th century, however, the *camera lucida* was also used by some of the most outstanding artists—French artists—and by no means only by amateurs.

Turning from dioptrics, or from refraction, to catoptrics, or reflection, two of the three divisions into which optics was divided up to the 18th and 19th centuries—well-illustrated in a frontispiece to a German treatise of 1710 [*Der dreyfach geartete Sehe-Strahl—The Ray of Vision in its Threefold Form*, published in Coburg]—in other words turning to the mirror which also since the days of the Renaissance played so important a role in the history of painting, we introduce another device that has often been linked, mind you superficially linked, with photography. Jean Cocteau, the old phrasemaker, wittily called photography "*Miroir reformant,*" a statement no scientist may find valid, since a comparison between diagrams showing the rays of the mirror reflection and the *camera obscura* refraction clearly reveals the basic difference between the two optical phenomena. Leon Battista Alberti, however, had linked the mirror so closely with the visual arts that in his *Trattato della pittura*, written about 1436, he called Narcissus, who fell in love with himself while viewing his image mirrored in the water, the true inventor of painting, as Leonardo called the reflection in the mirror the true painting and recommended the painter always to carry with him and to consult the mirror.

In any case, the mirror was for many centuries an important implement in the artist's studio and is still in use, foremost in England. [This may be seen in a photograph—published in *Architectural Review*, CI, No. 603, (March, 1947), 106—] of Graham Sutherland viewing his *Crucifixion* in Northampton's St. Matthew's Church with the help of a black mirror, which may have been invented in England, although its popular name, Claude mirror or Claude glass, bears the name of the French painter of the 17th century.

Thomas Gainsborough, whose landscapes were anything but mirror images of nature, depicted himself at least twice using a circular mirror. However, the frequent appearance of mirrors in self-portraits or portraits of artists ... does not only and does not necessarily refer to the particular self-portrait or portrait of the artist. This is a portrait of a painter by Christen Købke, the Danish painter, done in 1832, in which [a mirror] *Plate 16* appears, representing an important workshop aid. But [mirrors] also must be understood as an old emblem and symbol of the painter's craft and of his desired ability to create an image as faithful and truthful as the mirror image. And, therefore, it appears quite frequently in representations showing St. Luke painting the Madonna. At the same time, [the mirror] refers, as *speculum immaculatum,* to the virginity of the Mother of Christ.

Officially, photography, which Ruskin called "the most marvelous invention of the century"—later he modified his enthusiasm— may have been invented in 1839, but its intrinsic spirit is conspicuously present and apparent long before. The Dutch artist [J. Andriessen], who drew himself or a fellow artist with a *camera obscura* in his hand, died in 1819, or exactly *Plate 17* twenty years before Daguerre and Talbot would announce their invention to the world. How many more 18th and early 19th-century artists may have availed themselves of this device is left to our imagination or to our investigation.

In the 1820s and 1830s, pictures were painted or prints were made in which the specific characteristics of the photographic image—not necessarily of early photographs—were present, although photography was not yet invented and the aid of the *camera obscura* or of any other optical device had not necessarily been applied. Paintings of this kind may be found all over Europe in the decades immediately preceding the invention of photography, particularly in the 1830s. They appear in an almost mysterious way as precursors of the photographic spirit; at the same time pointing to one of the great problems of 19th-century painting: light and sun, which were also to become the active and operative forces of photography—first called "heliography" or "sun drawing" which a cartoon by George *Plate 18* Cruikshank, published in 1841, illustrates.

Plate 19 When we look at [this black and white slide], a painting by
John Constable, it may look to us very much like the photo-
graph of an elm tree. But the slide is made after a painting, the
colors of which when reduced to black and white increases the
photographic appearance of the picture. But it is not the quasi-
photographic texture alone which causes the optical decep-
tion. It is also the motif itself and its treatment: the abundance
of the details caused by the closeness of the painter to his sub-
ject; the portrait of an individual tree trunk which creates an il-
lusion with which we have become familiar through photog-
raphy. Yet the painting—an early work by Constable, who, in-
cidentally, as a young unskilled apprentice reinvented one of
Dürer's *machines à dessiner* which he did not know—was
done about 1821, or almost two decades before photography
was invented.

Plate 20 This painting by the Austrian painter Ferdinand Georg
Waldmüller, bearing the date 1834, has some features in com-
mon with the Constable picture. The same photographic qual-
ities may be observed in other paintings by Waldmüller, who
used the *camera obscura* and/or the black mirror, for instance
in his *Landscape near Gastein,* painted in 1837. What makes
this painting and many others done in the 1830s—the last pre-
photographic decade—so "photograph-like" is not only the
richness of details which the camera would record indiscrimi-
nately, but also the segment which seems to be confined to the
mere unchanged rendering of the unarranged image as it is
caught by the visual pyramid. There are no wings of any kind
enclosing or flanking the scene cut out from nature; no solitary
trees or groups of foreground trees leading into the back-
ground. Instead, it reveals an approach which this *Punch* car-
toon of 1953—which also reminds us of New Hampshire's
license plate—illustrates better than words can do.

These photographic qualities are by no means confined to
paintings by Austrian or South German artists. They can be
found as well, or even more frequently, in paintings by North
German painters, such as Eduard Gaertner whose *New Guard-*
Plate 21 *house in Berlin* was painted in 1833. Another painting, mind
you not a photograph, is the work of a little-known Berlin
Plate 22 painter, Johann Erdmann Hummel—and not by Andrew

Wyeth! It was done between 1830 and 1832. The crystal clear sharpness and precision of the Gaertner painting is reminiscent of paintings by Bernardo Bellotto, Canaletto's nephew, who, for which we have documentary proof, availed himself of the *camera obscura*. The richness of detail and the seeming accidentalness of the composition all correspond to Nicéphore Niépce's desire "to copy nature with the greatest fidelity," words which were almost identically pronounced in Waldmüller's manifesto.

If we go further north, we find the same tendencies in Scandinavian paintings of the 1830s. There are no artificial wings flanking the composition of Wilhelm Eckersberg's *View from the Three Crowns Battery towards Copenhagen*, painted in 1836. Light plays an important role in this picture not enlivened by figures, while the reflection of the Castle of Frederiksborg in a Christen Købke painting of 1835, conspicuously presents another optical phenomenon foretelling a future favorite motif of photography and tourists.

Plate 23

Plate 24

Still another painting by Christen Købke, painted in 1838, one year before the invention of photography was [announced], is reminiscent of the Wilhelm Eckersberg's picture painted two years earlier. Note the emphasis of the vertical centers—the lamppost and the flagstaff, respectively—and the close immediacy between the painted foreground, the imaginary "make believe" world, and the world of reality. These features are also not limited to Scandinavian and German art of the 1830s. To add a French example, Corot's painting of 1833, *Factory and Mansion of Monsieur Henri*, is a document of an almost detached objectivity and at the same time, through its subject matter, a sociological document of the early Industrial Revolution comparable to Turner's *Rain, Steam and Speed*, painted in 1844.

Plate 25

Plate 26

It has been rightly observed that Hill and Adamson, the Scottish photographers or calotypists, studied for the grouping and compositions of their portraits the paintings of their compatriots, among them, mainly, the works of Henry Raeburn, the most prominent figure in late 18th and early 19th-century Scottish portrait painting. Raeburn died in 1823, sixteen years before photography was invented and exactly twenty years be-

fore Hill and Adamson began their photographic collabora-
tion. It is surprising, therefore, to note how some of Raeburn's
Plate 27 portraits, probably done under strong top light, created effects
Plate 28 anticipating certain characteristics of the Hill and Adamson
photographs. Here we are faced not with the problem of the
impact exercised by photography on painting which becomes
so important a problem in the second half of the 19th century,
but with the anticipation of photography noticeable in paint-
ings of the 1820s and particularly of the 1830s, the last pre-
photographic decade.

This phenomenon has hardly, if at all, been noticed, and cer-
tainly has not been investigated from the points of view of the
imminent intrusion of the picture-making machine into the
realm of art and the interdependence of art and science. But it
has not remained completely unnoticed. Charles Blanc, the
founder of the *Gazette des Beaux-Arts,* wrote to the painter Er-
nest Meissonier, "Cher maitre, vous avez deviné la photo-
graphie trois ans avant qu'il y eut des photographes"— "Dear
master, you have foreseen photography three years before
there were photographers, or before photography was in-
vented." It may be hazardous to enter the controversial and
precarious territory of historicism and to speak about the artist
as a prophet of things to come, or even about the spirit of time.
But on the other hand, to quote William Barrett, "Art is not a
mere matter of conscious will." Nobody has yet been able to
give a truly convincing and plausible explanation for the riddle
of styles and their changes, which William Hogarth had hoped
to stabilize when he wrote his *Analysis of Beauty with a View
of Fixing the Fluctuating Ideas of Taste.* So let me conclude this
short talk about a topic I've barely touched upon with a
strange and beautiful sentence by Novalis, the German
Romantic poet, a sentence evoking the fathomless reaches of
the unconscious and of intuition: "The artist knows much
more than he knows that he knows."

—Edited transcription of taped lecture, "Before 1839:
Symptoms and Trends." Presented at a 1964 sympo-
sium at The International Museum of Photography at
George Eastman House (Rochester, N.Y.).

ART AND PHOTOGRAPHY: FORERUNNERS AND INFLUENCES

I N 1859, NADAR published a cartoon the caption of which reads: *La Peinture offrant à la Photographie une place à l'Exposition des Beaux Arts.* It was a highly personal *Plate 29* document. Nadar's portrait photographs of French and foreign celebrities, which were exhibited that year, had aroused enthusiastic comment by the public and the critics. In fact there seemed to be no limit to the praise which met these products of the camera. An overzealous critic called Nadar "the Titian of portrait photography," just as twenty years earlier Daguerre's works had been compared with Rembrandt's etchings, and a few years later Julia Margaret Cameron's photographs were to be compared with portraits by Holbein, Leonardo and Velázquez.

One voice, however, stood out in this confusion caused by the sudden and irresistible intrusion of the machine into the realm of art: that of Baudelaire, who in 1859 wrote his now famous letter to the editor of the *Revue française*. The essence of this letter, later published in his *Curiosités esthétiques* under the title, "Le public moderne et la photographie," is contained in this sentence: "We must see that photography is again con-

fined to its real task which consists in being the servant of science and art, but the very humble servant like typography and stenography which have neither created nor improved literature." The impact photography already had exercised in the past and was in the future to exercise on art and, beyond the world of art, on the whole spiritual development, was much too strong and deep to be stopped by Baudelaire's rather lonely appeal and rejection. The impact had by no means even reached its peak. Less than twenty years after Baudelaire's letter to the *Revue française,* Gaston Tissandier wrote in an article on photography and art: "It is certain that no painter at this day, whatever may be his talent, attempts to paint a portrait without having good photographic likenesses of his sitter;" or another testimony, this time an English one, also from the late 1870's: "... Let the photograph be accurately copied with the brush ... and then there is no reason why it should not be received in any art gallery in the world."

In view of such conceptions and statements, which could be supported by innumerable other quotations, it is surprising that the history of art has hardly devoted any attention to the question of art and photography, actually one of the paramount problems in 19th-century art, although its roots are infinitely older than photography itself. In fact the problem confronting us goes back to the days when, to quote Panofsky, "the Renaissance established and unanimously accepted what seems to be the most trivial and actually is the most problematic dogma of esthetic theory: the dogma that a work of art is the direct and faithful representation of a natural object." Thus the issue clearly arose as soon as Alberti formulated the doctrine of the visual pyramid and, deriving from this perception, described mechanical devices such as the *velo* and *reticolato* destined to assure the artist of scientifically—or rather mathematically—correct representations of his visual sensations. Not too long after the introduction of these devices, which may be called the first and basic *machines à dessiner,* artists became aware of the phenomenon of the *camera obscura,* which up to that time had occupied the minds of scholars in the fields of optics and astronomy rather than painters. Both these contrivances, the *machine à dessiner* and the *cam-*

era obscura, were symptoms of the ever-growing link between science and art and may be considered as distinct forerunners of photography. Both of them in all their varied forms were optical aids used by painters and draftsmen ever since their environment had become to them a world of visible facts rather than a world of symbols, and the desire for the scientifically exact copying of nature had replaced the fundamentally different approach of the medieval artist. Through the technique of photography the principles initiated in the days of the Renaissance reached their climax and limits and were, so to speak, led into absurdities, thus preparing the ground for the new approach and turning point at the beginning of the 20th century, which may be typified by the proclamation of the German expressionists in 1907: "Today photography takes over exact representation. Thus painting, relieved from this task, gains its former freedom of action."

A brief glance over the use of the *machine à dessiner* and the *camera obscura* may indicate that the tragic and sometimes tragicomic conflict between mechanical limitation and creative freedom resulting from the invention of photography was by no means a new one but had already existed for centuries in the seclusion of the workshops, studios and academies where these devices were used and handed down from master to student. Leonardo's *vetro*, or glassplate, and Alberti's *velo* and his squared frame were the first clearly described examples of *machines pour dessiner* as they were actually called in France in the 17th century. We are more familiar with the woodcut illustrations of four of these devices which Dürer published in his *Underweysung* in 1525, although only one of them is based on his own invention. Some of them survived as aids for three or four centuries without undergoing any essential change. Modified and improved examples may be found described and depicted in many treatises on perspective, such as Jean Dubreuil's *Perspective pratique*, first published in 1642, or Abraham Bosse's illustration in his *Divers manières de dessiner et de peindre* (1667?). Another 17th-century contrivance of this kind is Christopher Wren's little-known drawing aid of 1669, based like many others on Lodovico Cardi's invention but, in its principles, not too different from Egnazio Danti's device

Plate 30

Plate 13
Plate 14

first published in 1583. There are many others, most of them
developed from Alberti's, Leonardo's and Dürer's principles,
others based on somewhat different conceptions—but all
created out of the desire to assure a faithful and true transfor-
mation of the visual image into the preparatory or final work
of art. The closer the day of photography's invention ap-
proached, the more complicated and involved became these
machines à dessiner. In 1806, three or four decades before
Daguerre's announcement of his invention, Carl Schmalcalder
Plate 15 submitted his monstrous *Profile Machine* to the London Patent
Office, and a revealing caricature of about the same date
ridiculed an imaginary invention, "Limomachia," "by which
the usual objections to the Art, *viz.* Time, Trouble, and Ex-
pence" were entirely removed from the task of the "Portrait-
Grinder."

Even more obvious, of course, is the traditional line leading
from the *camera obscura* as a device to aid the artist, to pho-
tography which enabled man to make permanent the image de-
signed by the sun. Through photography, sun and light, which
were to become the central problem of 19th-century painting,
emerged as the very creating force in producing images. In fact
photography in its infancy was called "heliographic art,"
"solar engraving," and "sun painting," and a cartoon by
Plate 18 George Cruikshank published in 1841 illustrates what Al-
phonse Lamartine called "even more than an art but a sun
phenomenon in which the artist collaborates with the sun."
Long before that time, in 1568, Daniele Barbaro had advised
the draftsman to use the *camera obscura* for the study of nature
and to derive from it knowledge of the exact appearance of
things, their movements and colors; and at the beginning of the
17th century Christopher Scheiner stressed the usefulness of
the dark chamber for the *ars pingendi*. The phenomenon on
which the camera is based, however, had been known to sci-
ence long before the 16th and 17th centuries and had been in-
vestigated and described in the great optical treatises of Ara-
bian scholars and their northern followers and disciples Roger
Bacon, Vitellio and Peckham, whose writings were well known
to Leonardo and extensively used by him in his own investiga-
tions. Leonardo's manuscripts thus comprise many notes on

the *camera obscura,* although they do not yet refer to its use by, or usefulness for, the artist and are limited to the observation and explanation of the optical phenomenon. In the 17th century the camera became a rather widespread implement of the artist's studio after it had changed from an optical chamber, or *camera immobilis,* to a movable instrument, the *camera portabilis,* amazingly similar in appearance to the future photographic camera. In the 18th century the camera was an almost indispensable part of many artists' equipment. It appears in the mezzotint portrait of the German painter, Joachim Franz Beich (1665-1748), next to his crayon and maulstick, and in a painting of 1764 by Charles-Amédée-Philippe Van Loo in the National Gallery at Washington it is enjoyed as an optical toy by the artist's children. Its various forms differ greatly, although its basic construction was established in the 17th century and remained almost unchanged until the middle of the 19th. It was either just a portable box or in the shape of a tent, a form originally devised by Johannes Kepler and modified later so that it could be adjusted to a drawing table; it could be built into a *porte-chaise;* and there is even an 18th-century description of a camera built into the top of a carriage. The actual use of the camera by a draftsman may be seen in a German engraving of 1769, depicting a more elaborate device with extensions to assure exact focusing. The *camera obscura* was used in many paintings, drawings and prints from the 17th to the 19th century. We have documentary proof that Canaletto and Guardi made use of the camera, but this practice was not confined to the Venetian *vedutisti;* Crespi, Claude-Joseph Vernet, Loutherbourg and many less well-known painters resorted to this aid. In this country Benjamin West and his master, William Williams, were among them, and so were Gilbert Stuart and his teacher Cosmo Alexander. Reynolds, whose camera is still preserved, may be mentioned as the outstanding advocate of the instrument in England, where it was particularly popular among artists and amateurs.

How much stronger and deeper, therefore, must have been the influence of photography on 19th-century art and artists after Daguerre's and Fox Talbot's inventions had enabled man to make permanent the hitherto evanescent image appearing in

Plate 31

Plate 32

Plate 33

the *camera obscura*! The interrelation between photography and art may be studied in such varied aspects that only a few examples can be presented here. Photography's influence on art and life in the 19th and 20th centuries meant damage and service, confusion and clarification, weakening and strengthening, love and hate, envy and jealousy. The reflection of this dualism may be found in such utterances as Paul Delaroche's overhasty and yet somehow prophetic words spoken after the announcement of Daguerre's invention: "From this day on, painting is dead." Against this may be set Daumier's equally pessimistic words: "Photography imitates everything and expresses nothing—it is blind in the world of spirit." As manifold as the trends of the century were the mutual attitudes between photography and art, ranging from complete submission to defiant hostility or complacency and aloofness.

Every scientific advance entails renunciation or even abandonment of formerly well-established values. In the second half of the 19th century photography took over large domains hitherto firmly occupied by painting and the graphic arts, primarily portraiture, so that in large cities ten, twenty or more portrait photographers but not a single professional portrait painter could make a living. It is not surprising, therefore, that the photographer soon began to trespass the limits of his craft and to intrude, under all kinds of pretexts, into the formerly exclusive realm of his venerable and so much older "relative" whom he was before long to consider a brother of equal standing. All the more so as the painter, on the other hand, had begun to look for and to find support in the photographer's work. Among such artists was Delacroix who, although clearly recognizing its mechanical shortcomings, welcomed photography and used photographs for his paintings in various ways. Many passages in his letters and *Journal* refer to the ingenious process, of which he wrote in 1854, "How I regret that so admirable an invention comes so late, at least for my purposes!" Ingres, whose affinity for photography may be less surprising, expressed his admiration with these words: "This is the exactitude that I would like to achieve!" (1850); or another time: "It is admirable, but one must not admit it." If Ingres could make such a confession, how much more readily would a

weaker creative force yield to the temptations of a "machine" able to conceal his deficiencies? Delacroix and Ingres were safe from being overcome by the dangerous impact of photography to which so many smaller personalities were more exposed and bound to succumb. The portrait of Hector Berlioz in the Musée *Plate 34* de Versailles, ascribed to Daumier, is little more than an enlarged painted replica of a Nadar photograph and is probably *Plate 35* the work of Courbet's pupil, André Gill, who seems to be responsible for other spurious Daumier paintings which have entered museums and monographs. How much more pretentious and ridiculous photography's ambitions had become in the 1850's may be exemplified by the juxtaposition of Rejlander's photograph of 1857, entitled *Two Ways of Life*, composed of no less than thirty negatives and once the pride and focus of admiration at many exhibitions, with its obvious source of "inspiration," or rather imitation, Thomas Couture's painting, popularly known as *The Romans of the Decadence*. There are other proofs that photography and painting were interlocked and that the common spirit of their time sometimes resulted in similar abstractions and comparable visual approaches. Manet may or may not have known Adolphe Braun's photo- *Plate 36* graph of the harbor of Marseilles when he painted his *Harbor* *Plate 37* *of Bordeaux* about ten years after the photograph had been taken. Likewise the relationship between Courbet's *Waves* and the seascapes composed by the English photographer and painter H.P. Robinson out of several negatives may or may not be a pure coincidence. In any case, it reveals how hard it may sometimes be to discern who followed and who was followed and proves how important a part the study of photography should be' for anyone concerned with 19th-century and contemporary art, and how justified and even understated was Alfred Lichtwark's admonition in 1907: "When a future history of art which knows the facts shall deal with painting of the nineteenth century, it will have to devote to photography a special detailed chapter embracing the period from 1840 to the end of the century."

For even the greatest painters of this period could not keep clear of photography's impact. Degas' *Portrait of a Woman* in *Plate 39* the Tate Gallery, London, was not done from life but was a *Plate 38*

hardly successful excerpt from a photograph by Disdéri, which makes us realize why a good many of its features are not clearly materialized and appear rather unorganic. Photography was to remain an important formative influence in Degas' later work. A painting like the *Carriages at the Races,* in Boston, was based on a photograph as were many others. Their conception, that is to say their often casual views, with figures and objects cut by the frame and removed into a corner of the picture plane, reflects the instantaneous and accidental qualities of the photographer's work. It is therefore one of the reasons why Degas, himself an amateur photographer, eventually became the source of inspiration—or again rather of imitation—for a man like Robert Demachy, who gave up photography to become a painter, and who applied his half-mechanical, half-manual process "à la gomme bichromatée" to photographic ballet scenes *à la* Degas. Looking back to the 17th century we *Plate 7* may find in a painting like the *Soldier and Laughing Girl* by Vermeer (who very probably used the *camera obscura* for some of his paintings) a close relationship with such a painting as Degas' *Rehearsal.*

Post-impressionism too was sometimes dependent on photography. One of Toulouse-Lautrec's closest friends was the *Plate 40* photographer Paul Sescau, who took and at the same time appears in the photograph which the artist used as a basis for the *Plate 41* painting *A la Mie.* Utrillo is said to have used photographic views of Paris streets and street scenes by Eugène Atget and *Plate 43* others. A comparison between the painting by Henri Rous-*Plate 42* seau, *The Cart of Père Juniet,* and its photographic prototype reveals the limits of Rousseau's imaginative force and shows where imitation had to support and supplement his creative ability. There seems to be no end to the impact and influence of photography on 19th-century art, although its role undergoes so many transformations and shows so many variations, and although it approaches and intrudes upon the scene from so many angles and in so many disguises that such a short survey can present only a few aspects. Few admirers of Gauguin's art may ever have suspected photographic foundations in his *Plate 45* paintings, and yet a photograph made in his studio demon-*Plate 44* strates how his *Woman with Fan* must have come into being.

His Paris studio, in the midst of a vast amount of bric-a-brac, also contained a huge camera, and Gauguin was well aware of the trend of his time when he wrote to Charles Morice in 1903: "In art we have just passed a period of bewildered wandering caused by physics, chemistry, mechanics and the study of nature." What did this mean if not that 19th-century art had grown out of the associations formed by science and art?

The year in which photography was born, 1839, was also the birth year of Cézanne. His new approach was to become the turning point of a development which had been dominant since the Renaissance. Cézanne's painting meant the end of scientific perspective, the proclamation of a "truth" which could not be proved by figures, facts and diagrams. He replaced "reproduction" by "representation." It was the signal for a movement which wanted to escape from reality and sensuously recordable facts. It was the beginning of a revolution which, at least for some time to come, dethroned photography, the "evil spirit of the nineteenth century," as the almighty ideal: a revolution as sweeping and fundamental as that which had taken place in the late Middle Ages, when the subjective-symbolic view of physical environment yielded to an attitude towards nature that was naturalistic and objective.

—*Magazine of Art* 42:11 (November 1949).

VERMEER AND THE CAMERA OBSCURA

A FEW REMARKS, prompted by Charles Seymour's article on Vermeer and the *camera obscura* in *The Art Bulletin*,[1] may contribute some new information by which the question as to whether Vermeer availed himself of the *camera* could be somewhat further clarified. Charles Seymour answered the question in the affirmative while other scholars have come to different conclusions; that is to say, no agreement on this matter has yet been reached. Since I have devoted myself for many years to the problems of the interrelations between science and art, in particular to the use of mechanical devices by artists and the consequent impact on their work, this may be an appropriate occasion to call attention to a few facts derived from an extensive literary and pictorial documentation covering a wide span of pre- and post-photographic periods. Charles Seymour mentions in the very beginning of his excellent article that "for over thirty years the literature on Vermeer of Delft has included first hints, then suggestions and, finally, all but direct statements that Vermeer used . . . the *camera obscura* as an aid in making his paintings." It is possible in this connection to cite at least one statement in which, almost seventy-five years ago, the belief was expressed that Vermeer

Notes for this essay begin on page 151.

must have used an optical device in painting his *Soldier and*
Plate 7 *Laughing Girl.* The statement was made by Joseph Pennell, the
American etcher and lithographer, and it appeared, which is
perhaps also not without significance, in a photographic
magazine. In an article entitled "Photography as hindrance
and a help to art," published in *The Journal of the Camera
Club* (Vol. V, London, 1891, p. 75), Pennell writes: "... That
this perspective may be correct is possible since architecturally
trained draughtsmen who have not drawn from nature to any
extent render objects with photographic perspective. So, too,
did some old Dutchmen. There was a notable example in the
last exhibition of Old Masters at the Academy, in Vermeer's
Soldier and Laughing Girl.[2] But I think it extremely likely that
Vermeer used the *camera lucida,* if it was invented in his time,
for it gives exactly the same photographic scale to objects..."
 Pennell's statement itself makes it clear that he was not
familiar with the optical device Vermeer, in his opinion, may
have used, but what is important in this context is that Pennell,
long before anybody else, had sensed some unusual working
method used by this painter. It may be fitting to point out here
that, contrary to general belief, the *camera lucida,* which was
certainly not the device used by Vermeer, was already known
in his day. There are but few sources which do not assign the
invention of the *camera lucida,* which plays a certain role, par-
ticularly in the last decades of prephotographic time, to Wil-
liam Hyde Wollaston (1766-1828)[3] and Giovanni Battisti
Amici (1784-1863).[4] Actually, these two men introduced and
improved for practical use the *camera lucida* two hundred
years after it has been invented and clearly described by Jo-
hannes Kepler. In his *Dioptrice,* first published in Augsburg in
1611, Kepler gives an exact description of the *camera lucida*
after he had already three years earlier, by using threads, dem-
onstrated in his *Ad Vitellionem Paralipomena* the creation of
the image in the *camera obscura.* But Kepler's invention of the
camera lucida[5] fell into almost complete oblivion so that two
hundred years later Wollaston's and Amici's claims were not
challenged, although they were published as innovations in
several scientific journals and languages. The *camera lucida*
was also used by artists, as well as by amateurs, such as Sir

John Herschel, William Henry Fox Talbot, Basil Hall, and others[6] who needed this support for their limited abilities as draughtsmen. We have documentary evidence that, particularly in France, some outstanding artists of the second half of the 19th century made use of this optical aid. A discussion of these facts, however, may lead too far from Vermeer who, as before mentioned, would not have used *this* instrument, but the *camera obscura* which Pennell may have had in mind—provided Vermeer actually made use of this or any other optical device at all.

The history of art had hardly begun to examine the possibility of Vermeer's use of a *camera obscura* when Paul Claudel, who was undoubtedly unaware of this research, sensed the "photographic" quality in some of Vermeer's paintings. In a lecture Claudel delivered at the Hague on November 20, 1934, under the title: "Introduction à la peinture hollandaise," the poet referred to and elaborated on the unique "photographic quality in Vermeer's paintings":

> Mais ce n'est point des couleurs ici que je veux vous entretenir, malgré leur qualité et ce jeu entre elles si exact et si frigide qu'il semble moins obtenu par le pinceau que réalisé par l'intelligence. Ce qui me fascine, c'est ce regard pur, dépouillé, stérilisé, rincé de toute matière, d'une candeur en quelque sorte mathématique ou angélique, ou disons simplement photographique, mais quelle photographie: en qui ce peintre, reclus à l'intérieur de sa lentille, capte le monde extérieur. On ne peut comparer le résultat qu'aux délicates merveilles de la chambre noire et aux premières apparitions sur la plaque du daguerréotype de ces figures dessinées par un crayon plus sûr et plus acéré que celui de Holbein, je veux dire le rayon de soleil.[6a]

When these sensitive words were spoken, and printed the following year in *La Revue de Paris* (1 et 15 février, 1935), only one study had been devoted to Vermeer's possible use of the *camera obscura*, a source with which Claudel had hardly been familiar.[6b]

More important, however, may be another consideration
which to my knowledge has not yet been applied to the investi-
gation of Vermeer's possible use of the *camera obscura*. In
every recent Vermeer monograph, a passage from Balthasar de
Monconys' *Journal* has been quoted, from which we learn that
Monconys, during a visit in Delft on August 11, 1663, tried un-
successfully to acquire a painting by Vermeer. "A Delphes je
vis le Peintre Vermer qui n'auoit point de ses ouvrages; mais
nous en vismes un chez un Boulanger qu'on auoit payé six cens
livres, quoyqu'il n'y eust qu'une figure, qui j'aurois creu trop
payer de six pistoles." Balthasar de Monconys (1611-1665),[7] a
native of Lyon who became "conseiller du Roy en ses Conseils
d'Estat et Priué" and "Lieutenant criminel au Siège présidial de
Lyon," was not an ordinary traveller. He studied mathematics
and physics, began his travels as a young man in 1628, and un-
dertook extensive travels in 1645 and 1648, as well as towards
the end of his life in 1663 and 1664. He visited Portugal, Italy,
Egypt, Syria, Turkey, England, the Netherlands, Germany and
Spain. During his travels he met many of the great scientists of
his time, particularly physicists and chemists, and also many
painters and artists. Thus Monconys records in his *Voyages*
important observations on experiments of Robert Boyle,[8] and
correspondence and conversations with Thomas Hobbes,
Kenelm Digby, Henry Oldenburg, Dr. Thomas Willis and
Christopher Wren. He was also in contact with Pierre Gas-
sendi, Blaise Pascal, Athanasius Kircher, Andrea del Pozzo,
Evangelista Torricelli and Otto Guericke, in other words, with
some of the most distinguished members of Europe's scientific
and spiritual elite. This may also account for the lasting success
of his *Voyages*, which went through four editions (1665-1666,
1677, 1678, 1695) and also appeared as late as 1697 in a Ger-
man edition translated by Christian Juncker and published by
Andreas Zeidler in Leipzig and Augsburg.

Among Monconys' special interests was the field of optics
and the first volume of his *Voyages* contains letters and chap-
ters dealing with the construction of spectacles, microscopes
and telescopes.[9] Among the scientists whom Monconys con-
tacted at one time or another during his travels and with whom
he maintained relations were several scientists who had de-

voted themselves to the study and construction of the *camera obscura* and the *machines pour dessiner*. Among them were the German Jesuit Athanasius Kircher, who illustrated in his *Plate 47* *Ars Magna lucis et umbrae* (2nd ed., Amsterdam, 1671) a large *camera mobilis* in which a man could easily move around, and Christopher Wren, who devised a *machine à dessiner* "for *Plate 14* drawing the Out-lines of any Object in Perspective" which was published in the *Philosophical Transactions* (IV, For Anno 1669, London, 1670, pp. 898-899), but was constructed several years earlier. Wren's *Scenographe* or *Perspectographe*, a descendant of Alberti's, Leonardo's, Dürer's or Cigoli's *machines pour dessiner* was known to Monconys. "Pendant son voyage en Angleterre, en 1663, Moncony eut connaissance d'un instrument avec lequel on dessine très-exactement tout ce que l'on voit, par le moyen d'une règle que deux fils et un plomb tiennent toujours parallèle à l'horizon contre un châssis éléve perpendiculairement; c'est la machine à dessiner inventée par Hérigone,[10] mais bien perfectionée. En 1664, M. Oldenbourg, secrétaire de la Royal Society, envoya à Monconys une machine semblable construite par Thompson, sur laquelle on fixe perpendiculairement une espèce de pantographe inventé par Wren,[11] le célèbre architecte de Saint-Paul de Londres; il lui apprend aussi qu'on emploie, en Angleterre, un parchemin si bien preparé, qu'il est clair et transparent comme du verre, de manière qu'on pouvait copier toutes sortes de portraits et de gravures."[11a]

These observations illuminate the background which we must bear in mind when we quote the passage from Monconys' *Voyages* dealing with his short visit to Delft in 1663 and his interest in Vermeer's paintings. It does not prove that Vermeer used a *camera obscura*, a *machine á dessiner* or mirrors as optical aids, but the few facts, which could be easily expanded in various directions, show how much these instruments occupied the mind of Monconys and of other scientists and amateurs, as well as their painter friends in the 17th century, the time the Netherlands enjoyed scientific prominence in Europe. But it also shows that a truly thorough investigation of the work and lives of many artists will have to include the history of science, particularly when dealing with post-medieval

periods. Even the few observations of this note transform Monconys' short entry of his visit to Delft and of his attempt to acquire a work by Vermeer from a purely biographical and anecdotal detail into a more substantial record transcending the mere fact that Vermeer's paintings were scarce and expensive. They open a new vista, although they do not answer the question as to whether Vermeer availed himself of a *camera obscura* or any other optical aid, but they may, to a certain degree, add weight to the probability and offer new clues. At least the evidence makes it rather possible that one of Monconys' Dutch scientist friends may have called his attention to a painter in Delft who used with some amazing results an optical contrivance and that, therefore, his paintings may have had a particular interest and appeal to him. "... Monconys' visita beaucoup de curieux d'optique, examina divers genres de microscopes et de lunettes, fit, à Florence, la connaissance de Evangelista Torricelli qui luit vendit des lunettes. M. de Monconys ayant été curieux de lunettes et de microscopes, il a eu le premier, en France, des lunettes d'Eustache Divini à deux convexes dont il paya 13 pistoles, en 1650 ... Le beau-fils de Wiselius lui fit un microscope qu'il estimait beaucoup."[12] It is therefore not too farfetched, but rather likely, that Monconys visited Delft to call on the famous and "industrious naturalist and lens grinder, Antoni van Leeuwenhoek who, during his long lifetime (1632-1723), constructed 250 microscopes with over 400 lenses. On one occasion Leeuwenhoek presented 26 of his simple microscopes to the Royal Society of London to which he sent more than 300 letters" dealing with his investigations.[13]

Leeuwenhoek was an exact contemporary of Vermeer, their baptisms having been registered on the same page of the register of births of Delft's New Church. When Vermeer died at the early age of forty-three, leaving his widow and eight children, all under age, with an insolvent estate, the sheriffs of the city nominated Leeuwenhoek to act as "curator" or "official receiver." It can be safely assumed that the choice was not an accidental one, but that a relationship must have existed between the two men who had been residents of Delft all their lives.[14] If this assumption, which for the time being cannot be proven but

which may be considered most likely, could become provable by some kind of documentary evidence, the hypothesis of Vermeer's use of the *camera obscura* could find additional support. After the death of Leeuwenhoek, who survived his contemporary, Vermeer, by forty-eight years, his microscopes were sold at auction in the chamber belonging to the artists' Guild of St. Luke, of which Vermeer had been a member since 1652 and at one time the head. Leeuwenhoek himself admitted in a letter to the secretary of the Royal Society, Henry Oldenburg (Letter 11, March 26, 1675), that he was a poor draughtsman. He, therefore, may have used some kind of mechanical aid in drawing his "little animals," but as he wrote to Oldenburg, he was "resolved not to let anybody know the method" he used, thus revealing a secrecy not uncommon to artists and draughtsmen who availed themselves of the *camera obscura*—and the photographic camera.

It is of minor importance here that, as has been stated, the subject of the *Soldier and the Laughing Girl,* like so many of Vermeer's other themes, also occurs in numerous Dutch 17th century paintings and that the dark foreground figure of the soldier is contrasted to the figure of the girl bathed in light. What matters more is that Vermeer's treatment of the subject differs greatly from that of the other artists as far as the composition is concerned. Even more important is the undeniable fact, to my knowledge hitherto unnoticed, that the girl and the soldier are proportionally and spiritually far apart. They seem to be the result of two separate "sittings" which have not been quite satisfactorily fused into one image. No other painting by Vermeer comprising two or more figures shows a similar lack of homogeneity and unification, for which the combination of two images gained in the *camera obscura* may be responsible.[15]

Some, but perhaps not sufficient attention has been paid to possible connections between Vermeer and his contemporary, Samuel van Hoogstraeten.[16] Hoogstraeten's interest in and preoccupation with optics, for which we have not only documentary proof through his pupil Arnold Houbraken (*De Groote Schouburgh,* Amsterdam, 1718-1720) and his own writings (*Inleyding tot de Hooge Schoole der Schilderkonst,*

Middelburg, 1641), but which is also fully evidenced by some
of his paintings and prints, may deserve more and renewed
study in the light of recent Vermeer research. Hoogstraeten's
Plate 46 so-called peep shows of Dutch interiors (London, Detroit, The
Hague), which were probably known to Vermeer, who owned
two portrait paintings by the Dordrecht master, are unique re-
sults of Hoogstraeten's interest in optics and illusions. As has
been rightly pointed out, Samuel van Hoogstraeten's "preoc-
cupation with perspective experiments such as peepshows
(and other optical phenomena) is paralleled in Carel Fabritius
who was in Rembrandt's studio at the same time." Carel Fab-
ritius, who had a decisive influence on Vermeer—paintings by
this artist were in Vermeer's estate—seems to have been also
deeply interested in "illusionistic perspective pictures" as the
only surviving one, *A View of Delft, with a musical instrument*
Plate 51 *seller's stall* (1652, London, National Gallery), possibly the
fragment of a once larger composition, may prove.[16a]

John Evelyn, the diarist and amateur scientist, who, with
Robert Boyle, Christopher Wren, Henry Oldenburg, and other
distinguished scientists, was one of the charter members of the
Royal Society and in 1672 its secretary, relates in his London
diary on February 5, 1956:

> Was shown me a pretty perspective and well repre-
> sented in a triangular box, the Great Church of Haar-
> lem in Holland, to be seen through a small hole at one
> of the corners, and contrived into a handsome cabinet.
> It was so rarely done that all the artists and painters in
> town flocked to see and admire it.

Only two landscapes, or rather city views, stand against the
majority of Vermeer's surviving paintings in which the human
figure predominates. Research dealing with Vermeer's possible
use of the *camera obscura* has been primarily devoted to the
latter group. Yet the two city views deserve equal, and in cer-
tain respects even more, attention since they may offer addi-
tional clues for this specific investigation.
Plate 48 As has been observed by Gowing and Seymour, the *View of*
Delft was painted from an elevated viewpoint, probably from

an upper-floor window of a house situated near the bank of the broad canal. Whether the painter also occupied a first-floor window while painting the *Street in Delft,* as has been stated,[17] seems less certain. It is more likely that the standpoint of the artist was in a room on the ground floor, only slightly above the street level. Thus the room opposite the group of houses in the Vermeer painting could have served not only as a studio, but also as a *camera immobilis.* With curtains drawn over the upper pair of squared windows and the wooden shutters closed—except for a small opening, possibly fitted with a lens—the reversed image of the street on the other side would have appeared on a screen or on the light wall of the dark room facing the street.[18] The use of such a *camera immobilis* for artists or draughtsmen had been recommended as early as 1568. There appeared in the same year, in Venice, the work of the Patriarch of Aquileia, Monsignore Daniele Barbaro, *La Pratica Della Perspettiva* which for the first time mentions (p. 192f.) the use of a convex lens and diaphragm for a *camera obscura.* The subtitle of the book, which went through several editions, emphasizes that it was "Molto Profitterole A Pittori, Scultori, Et Architetti." Barbaro describes the procedure in the following way:

Plate 49

> Having made a hole in the window of the room from which you wish to observe, as large as a spectacle glass, then take an old man's glass convex on both sides, not concave, like the glasses of youths with short sight, and when it is fixed in the hole, shut all the doors and windows of the room so that no other light may enter except by the lens. Now take a sheet of paper and place it in front of the glass so that you see clearly all that is outside the house. This takes place most distinctly at a determinate distance, found by bringing the paper nearer to or farther from the glass till you have found the proper position. Here you will see the images on the paper as they are, and the gradations, colours, shadows, movements, clouds, the rippling of water, birds flying, and everything that can be seen. For this experiment the sun must be clear and bright,

because the sunlight has great power in bringing out
the visible images. When it pleases you to make the ex-
periment you should choose the glasses which do best,
and should cover the glass so much that you leave a lit-
tle of the circumference in the middle, which should be
clear and open, and you will see a still brighter effect.
(This seems to be the first mention of the use of a dia-
phragm in sharpening the image.) Seeing, therefore, on
the paper the outline of things, you can draw with a
pencil all the perspective and the shading and colour-
ing, according to nature, holding the paper tightly till
you have finished the drawing.
 (Translation of J. Waterhouse, I.S.C.).[19]

Barbaro's *Practica* was hardly the treatise frequently used by
17th-century Dutch scientists or painters. There were many
other books, however, which either depended on this first pub-
lication recommending and describing the *camera obscura* for
artists or which independently dealt with the subject. Choos-
ing just three works of the highest order out of a great number
of examples which could be named: Johannes Kepler's descrip-
tion of the *camera obscura* in his *Ad Vitellionem Paralipomena*
(1604), the German Jesuit astronomer and mathematician,
Christoph Scheiner, who in his *Oculus; Hoc est Fundamentum
Opticum* (Innsbruck, Daniel Agricola, 1619)[20] mentions the
usefulness of the "Cubiculum Hypocaustum" for the "ars
pingendi" and the distinguished French Minime (Franciscan
friar) mathematician and painter, Jean-François Nicéron, an
entry, incidentally, on whose death (September 22, 1646) may
be found in Monconys' diary (vol. I, p. 181, September 23,
1646). An illustration in Nicéron's *Thaumaturgus Op-
ticus . . . ad Cardinalem Mazarinum* (Paris, 1646, pl. 2, fig. 28)
shows how an image may be formed on a screen in a dark
room.[21] No doubt Antoni van Leeuwenhoek must have been
familiar with this famous book since Nicéron may also be con-
sidered an early pioneer in the history of the microscope, and
Vermeer might have seen and discussed the publication in
Leeuwenhoek's house. Neither the use by Vermeer of a *camera
immobilis* or a dark chamber, nor the use of a *camera portativa*

can yet be established by any unimpeachable documentary evidence or proof. A *camera obscura,* or for that matter any other optical contrivance left in Vermeer's estate, probably would have been listed in the inventory. But nothing indicating such an object appeared among the painter's equipment and tools in the itemized list of his assets. In any case, use by artists of the *camera obscura* was not uncommon in the 17th century (and even more in the 18th century), just as the *machines pour dessiner* were not exceptional since the days of Leone Battista Alberti *(Velo, Graticola)* and Leonardo da Vinci *(Vetro)* who devised their archetypes.[22] Even if the painting of landscapes in Johannes Kepler's tent camera or "Harmonica" (according to Sir Henry Wotton, *Reliquiae,* 4th ed., London, 1685, p. 300) may have been considered "illiberal," Sir Henry had to admit in his letter to Francis Bacon that "surely no painter can do them so precisely."

Plate 6
Plate 13
Plate 50

A letter by Constantijn Huygens (1596-1687) written in London, April 13, 1622, describes the beauty of the image in the *camera obscura.* The *camera* belonged to the Dutch physicist and inventor, Cornelis Drebbel (1572-1634), whom Constantijn Huygens had met in London.

> J'ay chez moy l'autre instrument de Drebbel, qui certes fait des effets admirables en peinture de reflexion dans une chambre obscure; il ne m'est possible de vous en declarer la beauté en paroles; toute peinture est morte au prix, car c'est ici la vie mesme, ou quelque chose de plus relevé, si la parole n'y manquoit. Car et la figure et le contour et les mouvements s'y rencontrent naturellement et d'une façon grandement plaisante. Les Degheyns s'y plaisent merveilleusement, mais notre cousin Carel s'y enragera...[23]

It would be surprising if the use of the *camera obscura* by Vermeer should have been a unique feat of this artist which did not have any precursors or followers. Johannes Torrentius' (1589-1644) circular still life of 1614 in the Rijksmuseum is hardly painted with the aid of a *camera obscura* as has been stated,[24] but reveals rather the use of an "old-fashioned," circular, con-

Plate 52

vex mirror. The application of the *camera obscura* in Dutch 17th century painting, however, points to another direction leading to the Venetian *vedutisti* of the 18th century.[25] Jan van der Heyden (1637-1712) who also painted in Delft seems to *Plate 8* have made systematic use of the *camera* in painting his city views with their sharp foreshortenings, thus forming a link between this branch of Dutch painting and Canaletto and his nephew, Bernardo Bellotto, who even made an etching after a *Plate 5* painting by Jan van der Heyden (De Vesme 34; Fritzsche VR 34).[26] It may be more than accidental that some still life paintings by Jan van der Heyden evoke Vermeer's style and approach. "He (Jan van der Heyden) was also a popular character owing to his being a clever mechanic, and did much towards improving the street lamps and the fire engines of the town."[27] The construction of, and experimenting with, a *camera obscura* may very well have been among the mechanical explorations of Jan van der Heyden who, incidentally, was the pupil of a glass-painter. Gaspard van Wittels (1647-1736), who came to Rome in 1674 and never returned to his native Holland, could be considered another link between the Northern and the Italian painters and etchers of *Veduti* who availed themselves of the *camera obscura* .[28] An unusual drawing by the Dutch landscape and portrait painter Jurriaen Andriessen (1742-1819), showing an artist with a *camera obscura*, also *Plate 1* points to Vermeer's homeland, where the use of this device may have had a long and continuous tradition since the 17th century. "There is a great deal of the history of the development of the viewing camera and its application to art still to be explored and unraveled, in particular the relationships in the seventeenth century between such experimental milieux as Rome and Paris and England and Holland." (Charles Seymour, Jr., *op cit.*, p. 324).

These few remarks, which could be greatly augmented by numerous other 16th, 17th, and particularly 18th century references, may strengthen evidence, if nothing else, that the *camera obscura* was not an uncommon instrument among studio paraphernalia. Even if they do not prove the use of the *camera* by Vermeer van Delft, they may add some new material and clues for a further investigation of the problem; but above

all, they may demonstrate the necessity of including the history of science[29] and its rich sources and findings in a future study of the history of art.[30]

—*Pantheon: Internationale Zeitschrift fur Kunst* XXIV: No. III (Mai/Juni 1966).

DAUMIER, GILL
AND NADAR:

MAN WAS THE sole theme in Daumier's work. There are no landscapes, no still-lifes among the paintings, drawings, and lithographs in which every aspect and phase of human life is mirrored. The garrulous, conceited lawyers, the silly fathers swollen with pride, the merciless landlords and their uneasy tenants, the pathetic appearance of the bourgeois families in the bathing establishments, the proud collectors looking over their treasures or showing them to their envious friends, the politicians and moralists unable to hide their own deficiencies, the vain little people who have risen to power and importance—the whole orbit of *Robert Macaire* and *Joseph Prud'homme* forms Daumier's endless procession of the human tragicomedy. Yet, the thousands of faces emerging from Daumier's grandiose panorama were never painted or drawn after nature. He confessed that he was just unable to do so. The resource of his unique creative power and of his unlimited imagination was his memory, his knowledge of form that derived from an unfailing and almost uncanny abundance of visions which could dispense with the support of the immediate model. Therefore the number of portraits rightly ascribed to Daumier is infinitesimally small compared with the enormous scope of his work. Even the most generous list of portrait paintings attributed to Daumier does not include more than a dozen likenesses.[1] Their number, however, shrinks to

one, or two, paintings after the list has been purged from spurious and questionable intruders. Thus it is not surprising that in the recent past the great Daumier exhibitions which were compiled with critical discrimination did not include any portrait paintings by the artist. Monographs and general books on French 19th-century art, however, still attribute to him a few of these portrait paintings the prestige of which seems to be supported and exalted by the names of the sitters.

Charles Baudelaire was among Daumier's most ardent admirers and had grasped his real stature when writing about him in his essay *Les Caricaturistes Français* (1857). What would have been more appropriate than to produce a portrait of Baudelaire by Daumier?[2] Charles-François Daubigny belonged to the select circle of artists and writers who saw in Daumier not a mere caricaturist like Charlet, Monnier or Gavarni, but a worthy descendant of Michelangelo, an artist whose power and imagination reached into the domain of the greatest among the old masters. Daubigny's often quoted exclamation in the Sistine Chapel, "That is like Daumier," seems to justify a portrait of that artist by Daumier[3] and at the same time to attest its authenticity. Although Théodore Rousseau was another friend of the artist, Daumier never painted the portrait which bears the obtrusive and uncharacteristic inscription: "A mon ami Th. Rousseau—H. Daumier."[4] A caricature portrait of the French socialist Louis Blanc, the brother of Charles Blanc, may belong in the same category;[5] although, on the other hand, it may be a genuine contemporary portrait later embellished and made more valuable by a signature and an exact date by which a closer link between the sitter and the painter seems to be established.

Plate 54

Another illustrious member of this questionable Daumier iconography was Alexandre Dumas, père. The portrait[6] presenting the writer in half-length, both his hands resting on the head of a cane, shows little resemblance to the rather unpretentious portrait paintings of Baudelaire, Daubigny, Blanc, and Rousseau. It is life-size and does not lack a certain vigor; yet its brush stroke and spirit, which may be called spectacular and obtrusive, exclude its attribution to the master. On the other hand, this painting, which cannot be traced beyond 1920, is

not necessarily the work of a professional or semi-professional forger specializing in Daumier portrait paintings, and its signature "H. Daumier" seems to be a later addition. A small group of other "Daumier portraits" two of which have even intruded into the sacred realm of museums may shed some light on the matter. The paintings of this group have some features in common: they are life-size portraits of outstanding contemporaries of the artist, they apparently do not appear in any book, magazine or catalogue published prior to 1900, and all of them seem to be derived and copied from photographs.

Hector Berlioz' portrait in the Musée de Versailles[7] which in 1901 was even admitted to the Daumier exhibition in the Palais de l'Ecole des Beaux-Arts has been proved to be copied from a photograph by Nadar. The photograph (or one of its several variants) was included in the memorable *3e Exposition de la Société Française de Photographie* of 1859 which inspired Baudelaire to write his famous essay *Le Public moderne et la photographie*, first printed in the *Revue Française* (June and July, 1859). A comparison between the photograph and the painting shows how the painter in every detail has remained dependent on his model, but also how every detail had become coarser and cruder in the painting, thus impairing the graphic and spiritual finesse of the photographic original.

Plate 34

Plate 35

It is hard to decide whether the portrait of Jules Michelet in the Städtische Kunsthalle in Mannheim[8] is by the same hand as the Berlioz portrait. It looks rather like the work of another, more skillful painter and seems closer to the "style" of the Dumas portrait. Be that as it may, it was again a well chosen subject for a Daumier portrait. For Jules Michelet, the French historian, belonged to the small circle of Daumier's devoted friends who, like Delacroix and Corot, like Baudelaire and Balzac, had at an early date recognized the greatness of the humble man. Daumier and Michelet met in 1851,[9] and the latter was to become one of Daumier's most ardent admirers and most faithful friends. "Vous étiez grand, et vous êtes sublime. Le Michel-Ange de la caricature. Ce nom vous restera... Je vous serre la main très tendrement," wrote Michelet to his friend in 1869.[10] Daumier could not have reciprocated this profession with so frivolous a likeness which distorts Michelet's sensitive

Plate 56

and spiritual physiognomy into a display of histrionic and sar-
castic features, alien to Michelet, as well as to Daumier. An

Plate 57 anonymous photographic portrait of Jules Michelet,[11] proba-
bly taken in the late 1850s or early 1860s, reveals the source
from which the painter of the Mannheim picture has borrowed
his motif. It may not have been too simple a task to translate
the details from the smooth photographic texture into a paint-
ing pretending a highly spontaneous "impressionistic" brush
stroke, although no detail seems to have been omitted by the
painter, and trace by trace every line and every area of light and
shade can be found in the photographic prototype. The cam-
era-made portrait, however, reveals more restraint and, at the
same time, offers deeper psychological insight than the preten-
tious "hand-made" picture. For Michelet actually faced the
camera, whereas the painter had to be satisfied with the image
the camera had yielded.

Henri Rochefort, who later in his life was portrayed by
Courbet (before 1870), Manet (1881, Hamburg, Kunsthalle)
and by Rodin (1891-1892), also appears among the subjects of

Plate 58 the pseudo-Daumier portraits. The painting, together with a
Gambetta portrait probably by the same hand, belonged to the
late painter-collector Richard Goetz, but both these pictures
disappeared during the last war.[12] As is the case with the
Michelet and Berlioz and probably also the Dumas portraits,
the Rochefort likeness seems to be based on a photograph. A

Plate 59 photograph—in reverse—by André Adolphe Eugène Disdéri
(1819-1890) seems to have been the model of the painting.[13]
Disdéri, who introduced the carte-de-visite photograph which
became so popular in the 1860s and 1870s, entertained a
studio which for many years was a landmark of the Boulevard
des Italiens. In spite of distortions and exaggerations distin-
guishing the painting from the photograph both have numer-
ous, often insignificant details in common: the general posture,
the costume, the hair-dress, the goatee which the painter seems
to have mistaken for a shadowed area, the hand in the pocket,
leaving only part of the cuff visible, and many other details.

The Rochefort portrait particularly, but possibly also the
Dumas and Berlioz portraits, may be the work of an artist who
has been named as the author of some of these simulated

Daumier paintings: André Gill, pseudonym for Louis-Alexandre Gosset de Guines, who for a short time had been a pupil of Courbet's and later in the 1860s and 1870s became a prolific contributor and illustrator of many magazines.[14] The Rochefort portrait with its over-sized head seems reminiscent of Gill's cartoons (published in *La Lune* (1866), *L'Eclipse* (1868-1876) and other periodicals of this kind) which frequently over-emphasized the head and dwarfed the body—a style going back to medieval illumination and often employed by Daumier and his contemporaries. André Gill's short life—he was born in Paris in 1840—came to an early and tragic end. In 1881 the artist had to be confined in Charenton, where he died four years later. In 1882 one of his paintings, *Le Fou*, still appeared in the *Salon*, but from then on his artistic activity seems to have been limited to his place of internment and did not reach the outside world. During these years, but possibly also before, André Gill may have painted portraits after photographs of celebrities he had known, some of which were abused by unscrupulous dealers and accepted by ignorant collectors and credulous connoisseurs. It may even be possible to detect some features in the Rochefort portrait which reflect and point to the painter's insanity and which are not apparent in the Disderi photograph. As a young man of eighteen, in 1858, André Gill had called on Daumier to get his advice since he too wanted to enter upon a *carrière* similar to that of his idolized master.[15] Ever after Daumier and Gill seem to have remained on friendly terms. Daumier also reciprocated the high esteem of the admiring disciple because Gill like himself was a staunch republican. When Daumier died Gill wrote a poem on the master's death and published it in the republican magazine *La Lune Rousse*(February 23, 1879), and at least some of the portraits looking like paintings by Daumier, but actually unlike any paintings ever done by him, seem to be strange documents of André Gill's admiration and homage for the great master.

Are there no genuine portraits by Daumier? Strange as it may seem, besides an early self-portrait[16] we know but one: the portrait of the wood-engraver and painter Hippolyte Lavoignat (1813-1896), painted around 1860 and now, as a

Plate 55

loan from the Chester Dale collection, in the National Gallery of Art in Washington.[17] It is unostentatious, yet powerful, painted with large brush strokes and built upon the contrasts of light and dark areas which are held together by an unfailing knowledge of form and an equally profound experience in tectonic values. There is no virtuosity as in the Michelet portrait, no distortion as in the Rochefort likeness, and no misunderstanding as we may find it in the Berlioz painting. It shows the "hand-writing" of the painter of *Le Wagon de Troisième Classe*, of the *Blanchisseuse avec l'Enfant* or of *Les Joueurs d'Echecs, L'Amateur d'Estampes* or the *Don Quichotte* and *Sancho Pansa* pictures, the grandeur of Daumier's sculptural conception and the monumental spirit that permeate his late paintings, drawings and lithographs.

II

No artist of the 19th century or of later days could evade the issue of photography. Consciously or unconsciously any artistic manifestation of that period—and indeed also of earlier and later ones—constitutes in one way or another acceptance or rejection of photography and what it stands for. Paul Delaroche's famous words spoken in the very hour of photography's invention: "From this day on, painting is dead,"[18] dramatically expose the problem which reaches deeply into pre-photographic times and foreshadows the tragic conflict to come. The documentary evidence—pictorial as well as literary—is overwhelming, but even so the history of art has shied away from this embarrassing and delicate issue and has only casually alluded to its implications. However, it is one of the great problems in a century in which the phenomena of light and sun had become a paramount problem and it remains the focal problem when a new approach turns against photography and violently repudiates any association with it. If only the weak and small talents among the artists had been forced by the impact of photography to abandon painting, sculpture or the graphic arts in favor of this easier means for producing images, then the history of art could easily exclude the topic from its problems and refer it to the subordinate domain of its

footnotes. But not only the small and weak talents succumbed to the machine which had intruded on the realm of art or who had found a convenient support for their lacking imagination and limited creative capacity. In fact, the greatest names of the 19th century appear when we investigate the influence photography had exercised on artists of the 19th century and to no lesser degree when we examine the influence painting had exerted on photography. Even if the painters and other artists could emancipate themelves in their works from the impact,they could not help writing or talking of the phenomenon, discussing its hazards and merits, its blessings, dangers, and shortcomings. How can we ignore an issue which has fascinated Ingres and Delacroix,[19] which has deeply influenced Corot's approach towards nature, which forms one of the fundamental aspects of Degas' creative will and style, which Cézanne, Gauguin and Toulouse-Lautrec struggled to overcome, but which—in rare cases, at least— they took advantage of, which Picasso could not completely ignore—to name just a few names? Yet it was not only an issue concerning artists. It goes far beyond the limits of that realm and reaches into every phase of our life, not only of our visual life and experiences. Like the fundamental change which had taken place in the days of the Renaissance, so photography and photographic vision have penetrated our mind and completely transformed our optical outlook. Although the last century has been called the "photograph-sodden age"[20] only few have seen the problem in its full importance and only few have dealt with it as lucidly and beautifully as a painter-philosopher: Albert Gleizes.[21]

It would be surprising if the phenomenon of photography and its consequences were not reflected in Daumier's work. And indeed they are.[22] As early as in the summer of 1840, less than one year after the announcement of Daguerre's invention to the French Academy of Science (August 19, 1839), the topic becomes the subject of one of Daumier's lithographs (L.D. 805) in *Le Charivari: "La patience est la vertu des ânes."* The lithograph, the third in the series *Proverbes et Maximes,* ridicules the long exposures which at that time were required to produce a successful picture with the aid of a Daguerre cam-

Plate 60

era. The man with the watch in his hand who is patiently awaiting the moment when the sun had finished the "painting" is undoubtedly Daguerre himself, but also his rather skeptic looking companion seems to be a portrait *charge*. Daumier, whose independence and imagination made him immune from the temptations to which so many smaller talents had succumbed, seems to have taken a rather pessimistic view of the blessings which photography had brought into the world. According to Charles Blanc, a disciple of Paul Delaroche and founder of the *Gazette des Beaux-Arts*, Daumier declared: "La photographie imite tout et n'exprime rien. Elle est aveugle dans le monde de l'esprit."[23] These words come strikingly close to what Daumier's ardent admirer Charles Baudelaire had to say about photography in his letter to the editor of *La Revue Française*,[24] but differs from the attitude Ingres and Delacroix had taken towards photography. In fact, photography did not yield much substance for Daumier's all-embracing panorama of the *Comédie Humaine*. Although his lithographs dealing in one way or another with photography cover the long period of a quarter of a century, from 1840 to 1865, they form but a tiny group within the vast expanse of Daumier's work and lack the passion pervading so many of his other topics. Two of them

Plate 61 (L.D. 1525, 2803) ridicule the head-rest,[25] the contrivance which was to assure a motionless posture of the sitter, but which looked like a medieval instrument of torture. Another pair of lithographs (L.D. 2445, 3416) satirizing human vanity in front of the camera seems to illustrate Baudelaire's words: "... la société immonde se rua, comme un seul Narcisse, pour contempler sa triviale image sur le métal."[26] The same theme appears in a woodcut illustration in *Un voyage d'agrément à Paris* (B. 729), published by the Musée Philipon in 1842 and in

Plate 62 a powerful drawing reproduced in the March 29, 1862 issue of *Le Monde Illustré* (B. 927). Two earlier lithographs which appeared in *Le Charivari* in 1844 (L.D. 1287) and 1846 (L.D. 1504), respectively deride the ignorance and narrow-mindedness of the bourgeois exemplified by their attitude towards the new invention of photography and its limitations.

One document, however, surpasses all the others Daumier had devoted to the subject. In 1862 Daumier published in the

newly founded magazine *Le Boulevard* a lithograph (L.D. 3248) [27a] which in a genial way takes issue with several aspects of photography. Its implications are quite manifold. It deals with aerial photography, which, together with the intrusion of Japanese art, was to have a decisive influence upon the new optical approach—the bird's eye view— of the Impressionist painters; it satirizes an actual personality among the early French photographers and his passion for showmanship; it ridicules the rapid growth of the photographic profession and in a sarcastic way raises the serious question whether photography should be considered an art or a purely mechanical procedure. *"Nadar élevant la Photographie à la hauteur de l'Art,"* *Plate 63* reads the caption of the lithograph which appeared in a magazine founded and edited by Etienne Carjat, who like Nadar himself was a writer, caricaturist and photographer— and a friend of Daumier's besides. The question as to photography's place in the realm of art is as old as photography itself, its implications as complex and inescapable as the permanent change of man's attitude towards and judgment of photography, its beneficial and detrimental faculties. Prevalence is followed by relaxation and finally the whole issue ceases to be essential, but before long the sequence may be reversed and aloofness may yield to acceptance and be finally followed by submission. Thus the question of photography's relation to art will never lose its justification and validity. On September 10, 1839, three weeks after Daguerre had made known his discovery at the memorable meeting of the French Academy of Science, *Le Charivari*, Daumier's *Charivari*, raised and discussed the question whether photography was to be considered a new branch of the Fine Arts. The answer was in the negative and somehow foreshadowed Baudelaire's ideas expressed exactly two decades later. "Considérée comme art, la découverte de M. Daguerre, est une parfaite niaiserie," writes the critic in *Le Charivari*, "mais considérée comme action de la lumiére sur les corps la découverte de M. Daguerre réalise un progrès immense." [27b] The books, lectures, articles, discussions and studies ever since devoted to the problem form a vast bibliography, not necessarily of strictly art-historical origin and character and therefore all but unknown even to the well-read expert.

The early Universal Exhibitions of the second half of the century, especially the Crystal Palace Exhibition of 1851 and the following exhibitions in London (1862) and Paris (1855, 1867, 1878), brought the dilemma into the open, as is clearly mirrored by the legal decisions of that period. In 1862, the very year Daumier published his Nadar lithograph in *Le Boulevard*, the Paris *Tribunal Correctionnel*[28] declared that photographs are not to be considered as works of art. In 1893 another court calls photography an art-like procedure,[29] but during the same period as well as earlier we may find voices praising photography and its merits in a manner which definitely elevates photography to the height of art. Thus Julia Margaret Cameron's photographs were compared with paintings by Caravaggio, Tintoretto, Giorgione and Velasquez,[30] with works by Holbein and Leonardo; O.G. Rejlander's photographs of nude children were called "as beautiful as (works by) ... della Robbia, Fiamingo and Raphael."[31] Jean-Louis-Henry Le Secq's fine photographs were confronted with drawings by Corot and Rousseau,[32] while Daguerre's works evoked in the mind of an English critic Rembrandt's etchings[33] and the calotypes of Hill and Adamson were compared with "Rembrandt's sketches."[34] It is not surprising therefore that photography soon appropriated the terminology of art: we read of the "camera artist" (1858)[35] or the "heliographic artist" (1864),[36] but in Nathaniel Hawthorne's novel *The House of the Seven Gables* (1851) the daguerreotypist Holgrave is simply called "the artist." A now famous photographer called his early pictures "Sketches"; some photographers, for instance Nadar, signed their photographs by hand within the representations as painters do and neither art museums and exhibitions, nor art journals could prevent photography's intrusion into their realms. Hence how could Nadar, who had been called "*le Titien de la photographie*"[37] and whose colors Ernest Lacan compared with Paolo Veronese's colors,[38] escape Daumier's all-embracing outlook and keen eyes which penetrated and unmasked every human folly or weakness?

Daumier may have taken a rather pessimistic view of photography's place in the sphere of art, but this did not prevent him from including some outstanding photographers among

his friends. Etienne Carjat, the editor of *Le Boulevard*, who also belonged to Manet's intimate circle,[39] was on friendly terms with Daumier and among his best photographic portraits were pictures taken by Carjat between 1860 and 1870. In 1859 or somewhat earlier Nadar received Daumier in his studio 35 Boulevard des Capucines, where this *"photographe artiste"* as the magazine *La Lumière* (IX, 1859, p. 56) had called him made at least four portraits of the great master. *Plate 64* They were among the many portraits which Nadar exhibited in that memorable exhibition of the *Société Française de Photographie* which was visited by more than 30,000 persons[40] and which established the fame of *"ce grand curieux"* Nadar.[41]

Three years later appeared Daumier's cartoon *"Nadar élevant la Photographie à la hauteur de l'Art,"* full of allusions and implications. The most humble and undemonstrative artist of his time depicts Nadar's sensational and much advertised balloon ascents which he undertook first with a *ballon captif,* later with a floating balloon, and which he made even more spectacular by taking photographic pictures from the air.[42] But the broadside also derides the frightening expansion of the photographic trade and profession. Nadar's balloon flies over a Paris each house of which seems to accommodate a photographic studio. This was certainly exaggerated, but if we study the statistics not only of Paris and France, but also of other cities and countries we may understand that the rapid growth and increase of professional photographers and in its train the steady decrease in the number of professional portrait painters, particularly in smaller communities, must have impressed or shocked men like Daumier. As early as in 1844 the *Annuaire de Commerce*[43] lists twelve professional photographers in Paris; a few years later Marseilles had four or five miniature painters doing mostly portraits while forty or fifty people exercised photography as a profession,[44] and in 1862, the year Carjat published Daumier's Nadar cartoon, Vienna counted 400 professional photographers.[45] Only a few years earlier, in 1855, Nadar himself had amused the readers of the *Journal pour Rire* with a cartoon: *Pluie des Photographes,* showing a *Plate 1* throng seeking refuse and protecting themselves with their um-

brellas against a swarm of photographers with their cameras falling down to earth.[46]

Mutual respect, however, must have linked Daumier and Nadar, who as ardent republicans were also politically congenial. One year before Daumier's death a committee was formed for a comprehensive exhibition of the old master who had been blind for some time and only through Corot's delicate generosity had been saved from want and destitution. Nadar was among the members of the committee, which was headed by Victor Hugo. A few years earlier Claude Monet and his friends had experienced and benefited from Nadar's liberality. "Nous étions depuis quelque temps systématiquement refusés par le jury, mes amis et moi," writes Claude Monet. "Que faire? Ce n'est pas tout que de peindre, il faut vendre, il faut vivre. Les marchands ne voulaient pas de nous. Il nous fallait pourtant exposer. Mais où? ... Nadar, le grand Nadar, qui est bon comme le pain, nous prêta le local...."[47] Degas, Monet, Renoir, Sisley, Pissarro and Cézanne were among the members of the *Société Anonyme des Artistes Peintres, Sculpteurs, Graveurs* who could thus hold their first exhibition, the first Impressionist exhibition which took place in Nadar's studio, 35 Boulevard des Capucines, where Nadar had photographed the great masters of an earlier generation, the painters of French Romanticism and Realism. Delacroix, Corot, Courbet and Millet were among them, but also Doré, Jongkind, Meissonier and Guys, whose drawings formed the most precious part of Nadar's collection.[48]

Delacroix was particularly interested in photography and paid much attention to it in his writings, and his diaries as well as his letters are full of references to this topic. However, Nadar seems to have entertained closer relations with Delacroix' antagonist, Ingres, who admitted without hesitation his admiration for the new invention and made use of the support which photography offered to artists aiming—as Ingres did—at a precision which was to become one of the academic ideals of the bourgeois generation in the second half of the 19th century.[49] "M. Sudre, un de nos lithographes les plus distingués, a rendu ce tableau avec le plus remarquable talent. Chacune des épreuves de son œuvre ne s'est pas vendue moins de cent

francs. Il est le seul auquel M. Ingres, très-jaloux de son suf-
frage, permette de reproduire ses œuvres, comme Nadar jeune
est le seul photographe auquel il envoie toutes les personnes
dont il veut avoir la ressemblance parfaite. Les photographies
de Nadar sont si merveilleusement exactes, que M. Ingres, avec
leur secours, compose ses plus admirables portraits sans avoir
besoin de la présence de l'original."[50]

It may be difficult to find a more eloquent justification for
the necessity of including photography in any study and
examination of 19th-century art.

— *Gazette des Beaux-Arts* Series VI: Vol. XLIX
(February 1957).

NOTES
Daumier, Gill, and Nadar

1. Eduard Fuchs: *Der Maler Daumier,* New York, n.d., pp. 6, 27, 46 where recently expressed doubts as to the authenticity of the portraits of Dumas (pl. 4), Berlioz (pl. 5), Rousseau (pl. 6) and Michelet (pl. 7) are mentioned. Erich Klossowski: *Honoré Daumier,* 2nd edition, Munich, 1923, pp. 122-123.

2. Private collection, Paris. E. Fuchs, *op. cit.,* pl. 8.

3. Formerly Coll. Otto Ackermann, Paris. E. Fuchs, *op. cit.,* pl. 16a. Honoré de Balzac referred to Daumier in a similar way: "Ce garçon a du Michel-Ange sous la peau." R.H. Wilenski: *French Painting,* Boston, 1949, p. 212.

4. Louvre, Paris. E. Fuchs, *op. cit.,* pl. 6. E. Klossowski, *op. cit.,* no. 393. Raymond Escholier: *Daumier. Peintre et Lithographe,* Paris, 1923, p. 73. Charles Sterling in a letter to the author of this article, dated December 18, 1953, writes about the painting in which he sees similarities with Thomas Couture's painting style as follows: "... nous considérons ce tableau comme faux, ou plus exactement, son attribution à Daumier comme fausse ... il s'agit d'un honnête portrait d'un artiste contemporain de Daumier ..." *

 * "... we consider this painting a fake, ... or more exactly its attribution to Daumier is false. It is in fact a portrait by an artist contemporary with Daumier ..."

5. Paris Auction Sale, April 1, 1914, no. 17. E. Klossowski, *op. cit.,* no. 404 (Signed l. r.: "H.D." Paris, 13 janvier 1841 [?]).

6. E. Fuchs, *op. cit.,* pl. 4. E. Klossowski, *op. cit.,* no. 406 (Formerly Paul Rosenberg, Paris). The painting was first published by Charles Oulmont, "Un portrait d'Alexandre Dumas par Daumier," *Les Arts,* 1920, no. 186, p. 23. It was then in the Coll. Prozor. In 1926 it belonged to the Coll. Birger Christenson. *Galerie Mathiesen, Berlin, Honoré Daumier Ausstellung: Gemälde, Aquarelle, Zeichnungen,* February-March, 1926, pl. 93.

7. E. Fuchs, *op. cit.,* pl. 5. Emil Waldmann: *Die Kunst des Realismus und Impressionismus im 19. Jahrhundert* (Propyläen Kunstgeschichte), Berlin (1927), p. 411. In 1901 the painting was included in the great Daumier Exhibtion: *Syndicat de la Presse Artistique. Exposition Daumier. Palais de l'Ecole des Beaux-Arts,* mai 1901, no. 80. Its derivation from a Nadar photograph was first established by Heinrich Schwarz, "Art and Photography: Forerunners and Influences," *Magazine of Art,* Nov. 1949, p. 255.

8. E. Fuchs, *op. cit.,* pl 7. *Städtische Kunsthalle Mannheim. Vorläufiges Verzeichnis der Gemälde und Skulpturen-Sammlung* (1928), no. 33 (acquired 1912). According to the same catalogue p. 4, however, the portrait had already entered the museum in 1909. W.F. Storck ("Die Kunsthalle zu Mannheim," *Kunst für Alle,* XXXIV, 1918-1919, fig. p. 387 and text p. 383) compares the

pseudo-Daumier portrait of Michelet with the late Rembrandt ("... man denkt an Rembrandts Späzeit...").

9. *Daumier raconté par lui-même et par ses amis,* Genève, 1945, pp. 85-91. Among the best portraits of the French historian is Thomas Couture's Michelet portrait in the Musée Carnavalet.

10. "You were great, and you are sublime. The Michelangelo of the caricature. This name will remain with you ... I shake your hand tenderly ..." Loys Delteil: *Honoré Daumier,* X, Paris. 1926, no. 3707.

11. I am indebted to Beaumont Newhall for his kind assistance in locating the anonymous photograph in the George Eastman House Historical Photographic Collection, Rochester, N.Y.

12. A portrait painting of the popular and prolific writer Napoléon Lespès, dit Léo Lespès (1815-1875) who under the pseudonym "Timothée Trimm" contributed from 1862 to the *Petit Journal* seems to belong to the same group of paintings. The portrait, formerly in the Coll. Richard Goetz, bears the inscription "Timothée Trimm," but its features are quite reminiscent of Nadar's appearance. Compare André Gill's portrait *charge* of Nadar in *Les Hommes d'aujourd'hui,* 1878, repr. in Emile Dacier: "La photographie à travers l'image," *Annuaire Général et International de la Photographie,* XIV année, 1905, p. 18, and *25th Art News Annual,* XXV, 1956, p. 61, top ill. (fig. 8).

13. I should like to express my sincere thanks to Miss Lucile M. Golson who in cooperation with M. Jean Prinet of the Bibliothèque Nationale has kindly assisted me in my research on André Gill and has called my attention to the Henri Rochefort photograph by Disdéri.

14. A. Lods et Vega: *Un chapitre de l'histoire de la caricature en France: André Gill, sa vie, bibliographie de ses œuvres,* Paris, 1887.

15. For the relationship between Daumier and Gill see Jean Adhémar: *Honoré Daumier,* Paris (1954), pp. 49, 54, 56, 64, 68, 70. André Gill seems to have turned to portrait painting in the 1860's.

16. Musée Calvet, Avignon. J. Adhémar, *op. cit.,* pl. 5.

17. *National Gallery of Art. French Paintings from the Chester Dale Collection,* Washington, D.C., 1942, p. 25 (with provenance and bibliography). J. Adhémar, *op. cit.,* p. 53; pl. 151 (*"vers 1863"*). Hippolyte Lavoignat was one of the best wood-engravers of the romantic period and worked after Tony Johannot, Jean Gigoux, Charles-François Daubigny, Auguste Raffet, Ernest Meissonier and others. Emile Dacier: *La Gravure française.* Paris (1944), pp. 125, 127, 163.

18. Gabriel Cromer: "L'original de la note du peintre Paul Delaroche à Arago au sujet du Daguerréotype." *Bulletin de la Société Française de Photographie et de Cinématographie,* 3ᵉ série, XVII, 1930, p. 114f, and reprinted in *Revue Française de Photographie et de Cinématographie,* XI, 1930, pp. 235ff.

19. Beaumont Newhall: "Delacroix and Photography," *Magazine of Art*, XLV, November 1952, pp. 300-303.

20. R.H. Wilenski, *op. cit.*, p. 3.

21. Albert Gleizes: *Vers une conscience plastique La forme et l'histoire*, Paris (1932), pp. 243ff.

22. The following 8 lithographs deal with the topic of photography: L.D. 805 (1840), 1287 (1844), 1504 (1846), 1525 (1847), 2445 ([1853], 2803 (1856), 3248 (1862), 3416 (1865). Furthermore the two relief prints B. 729 (1843) and B. 927 (1862) are devoted to the same subject. The block of the latter is in the Collection Philip Hofer, Cambridge, Mass. The following two articles deal among others with Daumier's prints on photography: Emile Dacier: "La photographie à travers l'image," *Annuaire Général et International de la Photographie*, XIV, 1905, pp. 9-48; Gabriel Cromer: "La photographie par l'image," *La Revue Française de Photographie et Cinématographie*, XI, 1930, pp. 120, 154, 170, 204-206, 251-253, 266-268. The lithograph L.D. 1525 is also thoroughly discussed by Ynez Ghirardelli: *The Artist Honoré Daumier, Interpreter of History*, San Francisco, 1940, pp. 45-47 (pl. X).

23. "Photography imitates everything and expresses nothing. It is blind in the world of spirit." According to George Besson: *La Photographie française*, Paris (1936), who writes: "... tandis que M. Charles Blanc proclame après Daumier..." The passage in Charles Blanc: *Grammaire des arts du dessin, architecture, sculpture, peinture*, Paris, 1867, p. 709, where Daumier is not mentioned differs, however, somewhat from the above version: "... Et si la photographie est une invention merveilleuse, sans être un art, c'est justement parce que dans son indifférence elle imite tout et n'exprime rien. Or, là où il n'y a pas un choix, il n'y a pas un art...."

24. *Œuvres complètes de Charles Baudelaire. Edition critique.* F.F. Gauthier: V, Paris, 1925, pp. 236-243: *Le Public moderne et la Photographie.*

25. For the head-rest see Gisèle Freund: *La Photographie en France au XIXᵉ siècle*, Paris, 1936, p. 89 and pls. facing pp. 90 and 92, and Alex Strasser: *Victorian Photography*, London and New York (1942), p. 14. The head-rest also appears in a drawing by (?) Daumier, formerly in the Coll. Nadar which is repr. in E. Dacier, *op. cit.*, p. 16 ("M. Prud'homme devant l'objectif").

26. "... the foul society rushed, like Narcissus, in order to contemplate its trivial image on the metal." A few years earlier, in 1854, Sœren Kierkegaard had expressed an equally pessimistic view: "A double levelling down, or a method of levelling down which double-crosses itself. With the daguerreotype everyone will be able to have their portrait taken—formerly it was only the prominent—and at the same time everything is being done to make us all look exactly the same so that we shall only need one portrait." *The Journal of Sœren Kierkegaard*, A Selection edited and translated by Alexander Dru,

Oxford University Press, 1938, no. 1312.

27a. The second state of the lithograph formed part of the *Souvenirs d'Artistes* (367). The stone of the lithograph L.D. 3248 is now owned by E. Weyhe, New York. Etienne Carjat (1828-1906): editor of *Le Boulevard*, was active as a writer, lithographer and photographer. Among the prominent men of the art world who sat before his camera were Ingres, Delacroix, Millet, Corot, Courbet, Monnier, Gill, Baudelaire and many others.

27b. "Considered as art M. Daguerre's invention is total nonsense" ... "but if considered as the action of light on bodies, the invention of M. Daguerre realizes immense progress."

28. *Photographic Notes*, VII, 1862, p. 41.

29. *Photographische Correspondenz*, XXX, 1893, p. 364.

30. *The Art Journal*, N.S., 1868, p. 58. In a review in *The Photographic News*, XXX, 1886, pp. 2-4, Mrs. Cameron is called "in fact, a Whistler in photography."

31. *The Practical Photographer*, edited by Matthew Surface, VII, May 1896, pp. 113 ff.

32. Ernest Lacan: *Esquisses photographiques*, Paris, 1856, p. 87 f.

33. *Aldine Magazine*, London, Simpkin & Marshall, I, 1839, acc. to *Notes and Queries*, 8th ser., XII, July 3, 1897, pp. 5-6.

34. *The Edinburgh Review or Critical Journal*, LXXVI, *January 1843, no 154, pp. 327-328.*

35. *Photographic Journal*, IV, 1858, pp. 191-197.

36. M.A. Root: *The Camera and the Pencil; the Heliographic Art, its Theory and Practice in all Branches. With its History in the United States and Europe*, Philadelphia, 1864.

37. *La Lumière*, IX, 1859, p. 56. As late as in 1899 Nadar called a photograph of Frédérick Lemaitre, "par Carjat ample comme un Van Dyck, fouillé comme un Holbein." Nadar: *Quand j'étais photographe*, Paris, n.d. (1899), p. 215. Photographs of Daumier by Carjat are repr. in Beaumont Newhall: *Photography. A Short Critical History*, New York (1938), pl. 35 (dated 1861) and Helmuth Th. Bossert and Heinrich Guttmann: *Aus der Frühzeit der Photographie, 1840-1870*, Frankfurt a.M., 1930, fig. 106 (1870).

38. E. Lacan, *op. cit.*, pp. 126 ff.

39. Adolphe Tabarant: *Manet, Histoire catalographique*, Paris, 1931, p. 87. Marcel Guérin: *L'Œuvre gravé de Manet*, Paris, 1944, no. 67 (1860). For Manet and Nadar see R.H. Wilenski, *op. cit.*, p. 231 and Jean Adhémar: "Le portrait de Baudelaire gravé par Manet." *La Revue des Arts*, II, 1952, no. 4, pp. 250 ff.

40. *Gazette des Beaux-Arts*, XI, 1861, p. 241.

41. *Gazette des Beaux-Arts*, II, 1859, p. 296.

42. Heinrich Schwarz: "Nadar," *The Complete Photographer*, VII, 1943, issue 41, pp. 2665-2667 (with bibliography).

43. Georges Potonniée, *The History of the Discovery of Photography*, New York, 1936, p. 151.

44. Giséle Freund, *op. cit.*, pp. 14 ff.
45. *The International Exhibition of 1862. The Illustrated Catalog of the Industrial Department.* According to the more credible statistics in *Photographische Correspondenz,* XIII, 1876, p. 230, however, there were only 116 professional photographers in Vienna in 1862.
46. *L'Art vivant,* no. 230, mars 1939, p. 43.
47. "We have been systematically refused by the jury, my friends and myself. But what can be done? It is not enough to paint, one has to sell as well, one has to live. The dealers do not want us. We must exhibit, nevertheless. But where? . . . Nadar, the great Nadar, who is as good as bread, lent us his place. . ."
 Lionello Venturi: *Les Archives de l'Impressionisme,* II, Paris-New York, 1939, pp. 339-340.
48. Frits Lugt: *Les Marques des Collections,* Amsterdam, 1921, nos. 1928, 1929.
49. George Besson, *op. cit.* Gabriel Cognacq: "Ingres, Delacroix et la photographie," *Beaux-Arts,* no. 349, décembre 1, 1939, pp. 9, 14. In this connection also the analysis of Ingres' portrait of Madame Riviére (1805) by the English painter Walter Richard Sickert, who was himself a "photographic addict" deserves mention. Robert Goldwater and Marco Treves (ed.), *Artists on Art,* New York (1947), pp. 395 ff.
50.
 "M. Sudre, our most distinguished lithographer produced this picture, with the most remarkable talent. Each proof of his work sold for no less than 100 francs. He is the only one whom Mr. Ingres, very proud of his reputation, permits to reproduce his works, as young Nadar is the only photographer to whom he sends people of whom he wants to have a perfect likeness. The photographs of Nadar are so marvelously exact, that M. Ingres, with their help, composes the most admirable portraits without any need of the original's presence."
 Eugéne de Mirecourt: "Ingres," *Les Contemporains,* XXXVII, 1856, p. 24, note. For Jean-Pierre Sudre (1783-1866), "le lithographe d'Ingres" see Henri Beraldi: *Les Graveurs du XIX^e siècle,* XII, Paris, 1892, pp. 62 ff.

NOTES
Vermeer and the Camera Obscura

1. Charles Seymour, Jr., "Dark Chamber and Light-Filled Room: Vermeer and the Camera Obscura," *The Art Bulletin*, XLVI, Nr. 3, September 1964, pp. 323-331.
2. The painting was owned by Mrs. Joseph, in London, from 1881 to 1911, the year it was bought by H.C. Frick in New York.
3. Wollaston's patent is dated December 4, 1806. William H. Wollaston, Sec. R.S., "Description of the Camera Lucida. Communicated by the Author," *The (London, Edinburgh and Dublin) Philosophical Magazine*, 1st ser., XXVII, London, 1807, pp. 343-347, with pl. VIII. Idem, "Description of the Camera Lucida," *A Journal of Natural Philosophy, Chemistry and the Arts*, ed. by William Nicholson, XVII, June 1807, pp. 1-5 and pl. 1. The article is reprinted in *The Emporium of Arts and Sciences*, conducted by J. R. Coxe, II, Philadelphia, 1812, pp. 267-272. A French translation appeared in Charles Chevalier, *Notice sur l'usage des chambres obscures et des chambres claires*, Paris, 1829, pp. 44-51.
4. Giovanni Battista Amici, *Sopra le camere lucide*, 1819. "Mémoire de M. le Professeur J.-B. Amici de Modène, sur Les Chambres Claires de son invention. Traduit de l'Italien," *Annales de Chimie et de Physique*, XXII, 1823, pp. 137-155 and pl. II. Reprinted in Charles Chevalier, *op. cit.*, pp. 58-74. Improvements of Amici's *camera lucida* by Vincent and Charles Chevalier ibidem, pp. 76-86.
5. Edmund Hoppe, *Geschichte der Optik*, Leipzig (1926), pp. 26 f., 30: "Keplers Verdienste um die Optik sind vollständig in Vergessenheit geraten. So konnte es geschehen, daß, als Wollaston die *camera lucida* genau 200 Jahre später wieder einführte, sie als eine ganz neue Entdeckung betrachtet wurde, während er nur den Namen dafür angab." *
 * "Kepler's merits in the field of Optics have been completely forgotten. This is the reason why when Wollaston 200 years later reintroduced the *camera lucida* it was considered to be a brand new invention, although he only gave it its name."
6. Goethe recommended the *camera lucida* and *camera clara* to naturalists with little experience as draughtsmen. "Über die Anforderungen an naturhistorische Abbildungen im allgemeinen und an osteologischen insbesondere," *Goethes Werke*, Großherzogin-Sophie-Ausgabe, II. Abteilung, 12. Band, II. Theil, Weimar, 1896, pp. 142, 144, 145.
6a. "But it is not the colors I wish to entertain you with, despite their quality and the play between them, so exact and frigid that they seem to be gotten not by the brush but realized by intelligence. That which fascinates me is the pure look, stripped, sterilized, cleansed, of all matter, of such candor, in a way mathematical or angelic, or let us simply say photographic, but what a photography: in which

this painter retired in the interior of his lens, captures the outside world. One can compare the result only to the delicate marvels of the *camera obscura*, and to the first apparition on the Daguerreo-type plate of those faces drawn with a surer and sharper pencil than that of Holbein, I wish to say with the ray of the sun."

6b. "L'Oeil Ecoute," *Oeuvres Complètes de Paul Claudel*, XVII, Paris, Librairie Gallimard, 1960, p. 23f. As the earliest investigation of Vermeer's possible application of a *camera obscura* may be considered the article by P.T.A. Swillens, "Een perspectivische Studie over de Schilderijen van Johannes Vermeer van Delft," *Oude Kunst*, VII, 1929/30, Utrecht, pp. 129-161.

7. "In Delft lived the painter Vermer [sic] who did not have any of his works; but we have seen one at the baker's for which six hundred livres have been paid, although it did not have more than one face, for which I thought paying six pistoles would be too much."
The first edition of Monconys' *Journal des Voyages* (Lyon, chez Horace Boissart et Georg Remeys) was posthumously published "par le sieur de Liergves, son fils." The first part is dated 1665, the second and third parts 1666. The quoted passage appears in tome II, p. 149. Le Comte Arthur de Marsy, "Balthasar de Monconys. Analyse de ses voyages au point de vue artistique," *Bulletin de la Société des Beaux-Arts de Caën*, VI, 1880 (200 copies). *Les voyages de Balthasar de Monconys, documents pour l'historie de la science*, avec une introduction par M. Charles Henry, Paris, Librairie A. Hermann, 1887 (500 copies).

8. Robert Boyle mentions in his essay *Of the Systematicall or Cosmical Qualities of Things*, first published in Oxford in 1671, a box camera with lens for viewing landscapes. Although Major-General J. Waterhouse, I.A. "Robert Boyle's Portable Camera Obscura," *The Photographic Journal*, XXXIII, new ser., 1909, p. 333) claims that Robert Boyle's account was the first printed record of a porta-ble box camera which could be extended or shortened like a tele-scope it seems to have been preceded by some earlier accounts. Among the earlier descriptions Johannes Christophorus Kohlhan-sius, *Tractatus Opticus*, etc., Leipzig, 1663 may be named where a portable camera ("Cistellula parva") and a book camera ("Liber opticus") are described. Cf. John F. Fulton, *A Bibliography of the Hon. Robert Boyle, fellow of the Royal Society*, Oxford, 1932, where 9 editions of Boyle's *Systematicall or Cosmical Qualities of Things* are listed. Book camerae which became popular in 18th cen-tury England may be found in the Science Museum, South Ken-sington, London which owns the camera used by Sir Joshua Reynolds and in Harvard University (*A Catalogue of Some Early Scientific Instruments at Harvard University*, Cambridge, Mass., n.d., No. 10). Sir Joshua also owned William Storer's "Delineator" according to Horace Walpole's letters Nos. 1669 (Sept. 16, 1777) and 1673 (Sept. 21, 1777).

9. "Monconys avait rassemblé un nombre infiny de nouvautés en machines de mathématiques, expériences de physique, curiosités de chimie, etc," * Paul Lacroix (Bilbiophile Jacob). *XVIIme Siècle, Lettres, Sciences et Arts, France 1590-1700*, Paris, 1882, pp. 54f. * M. Moconys collected innumerable novelties of mechanics of mathematics, experiments in physics, curiosities of chemistry.

10. Rouget de Lisle in *Bulletin de la Société d'Encouragement pour l'industrie nationale*, 43e année, octobre 1844, p. 423. Rouget de Lisle refers to Pierre Hérigone, *Supplementum Cursus Mathematici, etc.,* Paris, Henry Le Gras, 1642, pp. 113f.: "De diuerses méthodes de prendre la perspectiue d'un object que l'on voit deuant soy." * * "The various methods of taking the perspective of an object we see in front of us."

11. R.T. Gunther, *Early Science in Oxford*, Parts III & IV, 1923, p. 276. Samuel Pepys recorded in his diary (April 30, 1669): "This morning I did visit Mr. Oldenburgh, and did see the instrument for perspective made by Dr. Wren, of which I have one making by Browne; and the sight of this do please me mightly."

11a. "During his trip to England in 1663, Monconys became familiar with an instrument with which one designs very exactly all that one sees; by means of the rule that two threads and a plumb will always keep parallel to the Horizon against a frame raised perpendicularly. This is the *machine à dessiner,* invented by Hérigone but quite refined. In 1664 M. Oldenbourg, secretary of the Royal Society, sent to M. Monconys, a similar machine constructed by Thompson, onto which one can fix perpendicularly a kind of pantograph, invented by Wren, the celebrated architect of St. Paul's in London; he also learned from him, that there is in England a parchment so well prepared that it is transparent like glass, so that one could copy all sorts of portraits and engravings." *Collection Jean-Alfred Nachet*, Paris, 1929, p. 123.

12. "M. Monconys often went to see optical curiosities, examined different kinds of microscopes and eyeglasses; in Florence he got acquainted with Evangelista Torricelli, who sold him eyeglasses. M. Monconys, because of his curiosity about eyeglasses and microscopes, was the first one in France to have eyeglasses from Eustache Divini, with two convex lenses for which he paid 13 pistoles in 1650. The son-in-law of Wiselius made a microscope for him, which he appreciated very much." Collection Jean-Alfred Nachet, *Ibid.*

13. Bern Dibner, *Heralds of Science*, Burndy Library, Norwalk, Connecticut, 1955. No. 189.

14. Clifford Dobell, F.R.S., *Antony van Leeuwenhoek and his "little animals,"* New York, 1932, pp. 28, 35f., 125, 342 ff., 345. A possible link between Vermeer and Leeuwenhoek has been discussed by C. Dobell and has been more recently emphasized by Lawrence Gowing, *Vermeer*, New York (1953), p. 69f.

15. Heinrich Schwarz, "Art and Photography: Forerunners and Influences," *Magazine of Art*, vol. 42, No. 7, November 1949, pp. 252ff. The lack of unification may also account for it that *The Soldier and the Laughing Girl* has been considered "not one of Vermeer's best paintings," Philip L. Hale, *Vermeer*, Boston-New York (1937), p. 122.

16. Edgar P. Richardson, "Samuel van Hoogstraten and Carel Fabritius," *Art in America and Elsewhere*, XXV, No. 4. October 1937, pp. 141-152. Clotilde Misme, "Deux Boites-à-Perspective Hollandaises du XVIIe Siècle," *Gazette des Beaux-Arts*, 1925, pp. 156-166. R.H. Wilenski, *An Introduction to Dutch Art*, New York, 1929, pp. 264-267. H.E. van Gelder, "Perspectieven bij Vermeer," *Kunsthistorische Mededelingen van het Rijksbureau voor Kunsthistorische Dokumentatie*, III, 1948, No. 3. Van Gelder's suggestion that some of Vermeer's paintings were made for peepshows was refuted by Kjell Boström and J.Q. Regteren Altena (ibidem. IV. 1949. No. 1-2, pp. 21ff.). Hoogstraten's painting *Corridor*, The National Trust, Dyrham Park, Gloucestershire (Repr. *Apollo*, LXXXI, May 1965, p. 362) may also be a fragment of a peep-show.

16a. Neil Maclaren, *The Dutch School, National Gallery Catalogues*, London, 1960, pp. 125ff. (Fabritius) and pp. 191ff. (Hoogstraten).

17. Lawrence Gowing, *Vermeer*, New York (1953).

18. In spite of certain compositional similarities between Vermeer's *Street in Delft* and several early paintings by Pieter de Hooch the viewpoints occupied by the latter always seems to be lower than in Vermeer's painting. Pieter de Hooch's paintings also lack the "strange and unique combination of mellowness and precision" (E.H. Gombrich) which distinguish Vermeer's paintings and contributed to the conjecture of his use of the camera. Hofstede de Groot (*A Catalogue Raisonné of Dutch Painters of the 17th Cent.*, I, 1907, pp. 579f.) also emphasized quite strongly the uniqueness and peculiarities of Vermeer's paintings without ascribing these features to the use of the *camera obscura* or any other optical device. The references about Vermeer's possible use of the *camera obscura* by A. Hyatt Mayor ("The Photographic Eye," *The Metropolitan Museum of Art Bulletin*, Summer 1947, pp. 15-26, especially p. 19f.) deserve particular mention and attention.

The remark by Sir Isaac Newton's friend Willem Jacob s'Gravesande (1688-1742) in his *Essai de Perspective* (1st ed., Paris, 1711) that "several Dutch painters are said to have studied and imitated ... the effect of the *camera obscura*" the effect of which "is striking, but false" (A. Hyatt Mayor, p. 20) should be supplemented by a reference by Pierre-Jean Mariette (1694-1744), whose biography of Canaletto was, according to Mariette's own statement, based on information received from the artist himself. "Il avoit fait

dans sa jeunesse le voyage de Rome, et, depuis qu'il eut abdiqué le théâtre, il ne s'occupa plus qu'à peindre des veues d'après nature, faisant usage de la chambre noire, dont il seavoit modérer le faux." * (Abecedario de Pierre-Jean Mariette et autres notes in-édites de cet amateur sur les arts et les artistes, I, Paris, 1851-1853, p. 298.) On the distortion of the camera obscura image see also Johann Georg Buesch (1728-1800). Encyclopaedie der ... mathematischen Wissenschaften, Hamburg, 1775, pp. 118f.

* "In his youth he travelled to Rome and since he had to resign from the theater he devoted himself totally to painting from Nature with the help of the camera obscura, the faults of which he was able to correct."

19. Daniele Barbaro's priority in applying a lens to the camera obscura is supported by statements of the Jesuits Marius Bettinus (Re-creationes Mathematicarum Apiaria Novissima Duodecim, etc., Bologna, 1645) and Gaspar Schott (Magia Universalis Naturae et Artis, 1657, Book VI, p. 329). They both refute Giovanni Battista della Porta's claim in his Magia Naturalis, sive Miraculis Rerum Naturalium, Napoli, 1558, Lib. IV, cap. 2, 143 to have been the first to apply a concave lens to his camera obscura immobilis. Yet even today statements may be found ascribing not only the applica-tion of the concave lens, but the invention of the camera obscura to Giovanni Battista della Porta whose Magia Naturalis was ex-tremely popular and appeared in numerous Italian, French, Ger-man, English, Spanish and even Arabic translations as late as in 1715. A French reprint was published even in 1913. Ernst Gerland, Geschichte der Physik, München-Berlin, 1913, p. 272. F. Paul Liesegang, "Die Camera obscura bei Porta," Mitteilungen zur Ges-chichte der Medizin und der Naturwissenschaften, XVIII, Nr. 80/81, 1919, Nr. 1/2, pp. 1-6.

Porta, incidentally, is among the earliest advocates of the camera obscura as an aid for painters. In his report on the Daguerreotypie made to the Chambre des Deputés even Dominique-François-Jean Arago referred to Porta as the inventor of the camera, Bulletin de la Société de l'Encouragement, Paris, 1839, p. 325.

20. A second edition appeared in 1621. An English edition, published in London by J. Flesher & Cornelius Bee in 1652, deals with the cam-era obscura in Liber III, Pars I, pp. 125ff.

21. Jean-François Nicéron's La perspective curieuse (1st ed. 1638; 2nd ed. 1651/52; 3rd ed. 1663) which also contains the Catoptrique of Marin Mersenne (1588-1648), an associate of Galileo and Des-cartes and translator of Galileo into French, deals with various machines à dessiner, particularly with Lodovico Cardi's device ("Instrument catholique ou universel de la Perspective"). Moritz von Rohr, Zur Entwicklung der dunklen Kammer (camera obs-

cura), Berlin, 1925, pp. 10f., Abb. 4. Philippe Daly, "Machines à Dessiner," *Arts et Métiers Graphiques,* No. 46, 1935, pp. 40f., fig. 8. Thieme-Becker, XXV, 1931, p. 440. On the relationship between Galileo and Lodovico Cardi see Erwin Panofsky, *Galileo as a Critic of the Arts,* The Hague, 1954.

22. "Leonardo also disapproves of those who rely on devices for exact imitation, like Alberti's net or method of painting on a piece of glass held in front of the view. They should only be used as shortcuts and labour-saving tricks by those who have enough knowledge of theory, that is to say above all of perspective, to be able to check their work according to scientific standards." Sir Anthony Blunt, *Artistic Theory in Italy, 1450-1600,* Oxford Paper Backs, p. 28. For Leonardo's statement see J.P. Richter, *The Literary Works of Leonardo da Vinci,* Oxford University Press, 1939, vol. I, p. 96f.

23. "I have, here, other instruments from Drebbel, which certainly produce admirable effects in painting the reflections in a *camera obscura.* It is impossible for me to speak about the beauty. All painting is dead, consequently, because this is Life itself, or something of higher level, if words were not missing. Because the figures as well as the contours and the movements meet each other naturally and in a greatly pleasing manner. The Degheyns are marvelously pleased, but our cousin Carel will be enraged. . . ."
 De Briefwisseling van Constantijn Huygens (1608-1687), edited by Dr. J.A. Worp. Eerste Deel 1608-1634, 'S-Gravenhage, 1911, p. 94, Letter 143. Constantin Huygens' statement on the effect of the *camera obscura* on painting prefigures Paul Delaroche's famous exclamation . . .: "From today on, painting is dead."

24. Jhr. B.W.F. Van Riemsdijk, "Een Schilderij van Johannes Torrentius," *Fest-Bundel Dr. Abraham Bredius angeboden den achtienden April 1945,* Amsterdam, 1915, pp. 243-249, pl. 97. Abraham Bredius, "Joh. Symonsz. Torrentius (Een Nalezing)," *Oud Holland,* XXXV, 1917, pp. 219-223, Walter Bernt, *Die Niederländischen Maler des 17, Jahrhunderts,* III, München, (1948), Nr. 839.

25. Heinrich Schwarz, "A Painting by Francesco Guardi," *Museum Notes, Museum of Art, Rhode Island School of Design,* Providence, vol. 10, No. 4, May 1953, pp. 1-3.

26. Giuseppe Fiocco, *Venetian Painting of the Seicento and the Settecento,* Firenze-New York, (1929), pl. 82 where paintings by Jan van der Heyden and Canaletto are reproduced together. L. Gowing, *op. cit.,* p. 70, note 9 quotes Maxime du Camp's, a photographer himself, remark about Vermeer's *View of Delft:* "C'est un Canaletto exagéré" (*Revue de Paris,* octobre 1857).

27. J.H.J. Mellaert, *Dutch Drawings of the 17th Cent.,* New York, 1926, p. 12.

28. "Die Maler, welche große Prospekte oder Aussichten verfertigen, haben solcher Kammern sich oft mit dem herrlichsten Nutzen bedient" (Franz Christoph von Scheyb, *Orestrio von den drey*

Künsten der Zeichnung. Wien, 1774, Zweyter Theil, S. 179ff.).
Heinrich Schwarz, "Zur Geschichte der Camera osbcura." *Die Galerie,* Heft 11, Jänner 1934, pp. LXXIX-LXXXIV. The work by Decio Gioseffi (*Canaletto, Il Quaderno delle Gallerie Veneziane e l'Impiego della Camera Ottica,* Trieste, 1959) which continues the investigations of Hellmuth Allwill Fritzsche (*Bernardo Belotto, genannt Canaletto,* Burg b. M., 1936) may be considered the most thorough and comprehensive recent study of the use of the *camera obscura* by the Venetian "vedutisti," particularly Canaletto.

29. Martha Ornstein, *The Role of Scientific Societies in the Seventeenth Century,* The University of Chicago Press, (1938), first privately printed in 1913, may still be considered an indispensable reference book.

30. As a comparatively early attempt of establishing a cooperation between the history of optics and the history of art a little known study by the Swedish writer Oscar Ivar Levertin (1862-1906) deserves mention: *Jacques Callot, Vision du microcosme.* Traduit du suédois par Mme Anna Levertin. Préface et notes de François-Georges Pariset, Paris, Libr. Stock, 1935. Cf. the review by René Huyghe in *L'Amour de l'Art,* vol. 17, oct. 1936, p. 307: "Levertin cherche en Callot le secret psychologique de cette vision du microcosme, si neuve alors: il y voit une des conséquences du mouvement scientifique et philosophique du temps, en particulier de l'invention du microscope, une manifestation graphique de l'esprit qui animait Galilée, Gassendi ou Pascal."* Cf. also *Gazette des Beaux-Arts,* série 6, vol. 13, novembre 1935, p. 188.

* "Levertin seeks in Callot's work the psychology of his vision of the microcosm, so new then: he sees in the consequences of the science and philosophy of the times, in particular the invention of the microscope, a graphic indication of the spirit that motivated Galileo, Gassendi and Pascal."

SELECTED BIBLIOGRAPHY

In addition to those references already identified, the following selected writings by Heinrich Schwarz, most of which he consistently listed in bibliographies of his writing on photography or photography and its relationship to traditional arts, are suggested for further reading:

David Octavius Hill, der Meister der Photographie (Leipzig, 1931).Translated by Hélène E. Fraenkel as *David Octavius Hill, Master of Photography.* London: George C. Harrap & Co., 1932.

"L'Oeuvre de Renger-Patzsch." *Bulletin de la Société Francaise de Photographie et de Cinématographie,* Tome XVII, No. 5 (Mai 1930), pp. 149-152.

"Uber Photographie." *Die Galerie* (Vienna), Heft 1 (März 1933), pp. I-IV.

"Om Fotografi." *Foto Tidskrift for International Fotografi* (Copenhagen), (Marts 1933), pp. 4-5.

"The Camera Obscura." *The Gallery* (London), Vol. 1, No. 9 (Nov. 1933), pp. 111 ff.

"Zur Geschichte der Camera Obscura." *Die Galerie* (Vienna), Heft 11 (Januar 1934), pp. LXXIX-LXXXIV.

"Hugo Erfurth." *Photographik* (Berlin), Heft 2 (Februar 1934), pp. 1-5.

"David Octavius Hill." *The Complete Photographer,* Vol. 6, Issue 31 (1941), pp. 1974-1978.

"Julia Margaret Cameron." *Ibid.,* Vol. 2, Issue 10, pp. 593-595.

"Nadar." *Ibid.,* Vol. 7, Issue 41, pp. 2665-2667.

"Calotypes by D.O. Hill and R. Adamson." *Museum Notes* (Rhode Island School of Design Museum of Art), Vol. 2, No. 8 (Dec. 1944), pp. 1-2.

"The Mirror in Art." *The Art Quarterly,* Vol. XV, No. 2 (Summer 1952), pp. 96-118.

Salzburg und das Salzkammergut: Die künstlerische Entdeckung der Stadt und der Landschaft im 19. Jahrhundert, 3rd Ed. Vienna: Anton Schroll, 1957.

"An Exhibition of Victorian Calotypes." *Victorian Studies: A Quarterly Journal of the Humanities, Arts and Sciences,* Vol. 1, No. 4 (1958), pp.354-356.

"William Etty's 'Self-Portrait' in the London National Portrait Gallery." *The Art Quarterly,* Vol. XXI, No. 4 (Winter, 1958), pp. 391-396.

"Hill-Adamson Calotypes." *The Scottish Art Review,* Vol. XII, No. 4 (1970), pp. 1-5, 33.

"The Calotypes of D. O. Hill and Robert Adamson: Some Contemporary Judgments," *Apollo,* Vol. XCV, No. 120 (Feb. 1972), pp. 123-128.

"An Eighteenth-Century English Poem on the Camera Obscura." In *One Hundred Years of Photographic History, Essays in Honor of Beaumont Newhall,* edited by V. D. Coke, pp. 127-138. Albuquerque: University of New Mexico Press, 1975.